GLOUCESTER AT WORK

PEOPLE AND INDUSTRIES THROUGH THE YEARS

CHRISTINE JORDAN

AMBERLEY

First published 2017

Amberley Publishing
The Hill, Stroud
Gloucestershire, GL5 4EP

www.amberley-books.com

Copyright © Christine Jordan, 2017

The right of Christine Jordan to be identified as the
Author of this work has been asserted in accordance
with the Copyrights, Designs and Patents Act 1988.

ISBN 978 1 4456 7086 7 (print)
ISBN 978 1 4456 7087 4 (ebook)

British Library Cataloguing in Publication Data.
A catalogue record for this book is available
from the British Library.

Origination by Amberley Publishing.
Printed in the UK.

CONTENTS

INTRODUCTION

Gloucester has been a centre for trade and industry since the Roman times, when the first 'factory', a legionary tile- and brickworks, was founded on the site of St Oswald's Priory. Shortly after the arrival of the Normans in the twelfth century, Gloucester had its own mint, where the skilled trade of the coiner was carried on. During the medieval period, various skilled trades developed. The most notable was that of stonemasonry, central to the building of the magnificent religious buildings that have made their historic mark on this city, leaving us with an architectural heritage to be proud of.

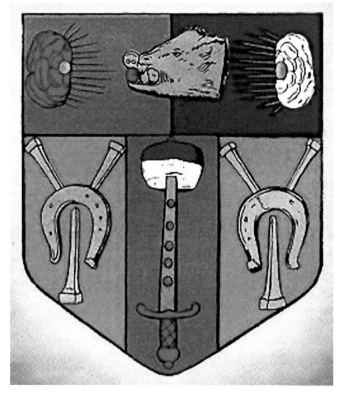

The city's coat of arms reflects the dominant trade of the era. The horseshoes and nails are symbolic of the twelfth-century trades of ironwork and smithery.

Other medieval trades such as tanning dominated in Hare Lane, due to its proximity to the River Twyver. The city became well known for bell-making, with the development of a bell foundry from as early as 1270. The popularity of wearing caps, combined with the Dissolution of the Monasteries, afforded one entrepreneur living in the city to turn Blackfriars Priory into a cap-making factory in 1539.

In the eighteenth century, pin-making remained the most significant manufacturing industry, employing large numbers of people, including women and children. At this time, Gloucester also benefitted from the wool trade, when wool-stapling became a dominant industry. The banking industry was firmly established in Gloucester by the late eighteenth century, with several banks operating and trading in the city.

The opening of the Gloucester & Berkeley Canal in 1827 gave the city a major role in the seagoing trade and laid the basis for its commercial and industrial expansion in the Victorian era. Timber merchants also carried on their trade from the newly built canal system. Major industrial concerns followed, as trade mushroomed around the dock area of the city. Flour and corn merchants built large brick-built mills along the canal-side. Later, in the 1860s, large engineering firms such as Gloucester Railway Carriage & Wagon Co. and Fielding & Platt set up, employing hundreds.

The outbreak of the First World War brought many changes to the labour market, bringing local women into the world of work. Previously working in domestic trades, women started work in their thousands at the munitions factory in Quedgeley, near Gloucester. The Second World War cemented women's position in the world of work with their involvement in the Land Army and their work as lumberjills.

Economic decline in the 1960s and 1970s saw many of Gloucester's major industrial concerns close down or reduce their workforce considerably. By the late 1980s, Gloucester had followed the national trend and heavy industry was in decline, being replaced largely by service industries.

From megalithic industrial concerns employing hundreds of people, to small family businesses, Gloucester has a wealth of industrial heritage. *Gloucester at Work* hopes to map some of the contributions made by entrepreneurs, engineers, innovators and skilled tradespeople, as well as the ordinary men and women who have contributed to Gloucester's – and the nation's – wealth by working in this great city.

PRE-INDUSTRIAL REVOLUTION

B efore the onset of the Industrial Revolution, people mainly worked at home or in small-scale productions known as cottage industries. However, in Gloucester, the very first industrial-scale business to be practiced was probably a Roman legionary tile- and brickworks founded on the site of St Oswald's Priory around AD 100. The brickworks appear to have continued production following the departure of the Romans and was run as a commercial concern to supply the *colonia* and the attached city with goods. A tile stamped 'RPG', or *res publica glevum*, meaning 'from the public works at Gloucester', found during excavations validated this. Evidence of pottery kilns has also been found outside the east gate of the *colonia*, which are thought to have produced their own distinctive Glevum ware.

During the Saxon period, when Aethelflaed founded St Oswald's Priory, highly skilled stonemasons were building and creating some of the most stunning religious buildings in the city. Stonemasons have been working on Gloucester Cathedral since its inception in AD 678 and continue to do so, largely using their skills for preservation and conservation of these magnificent medieval buildings.

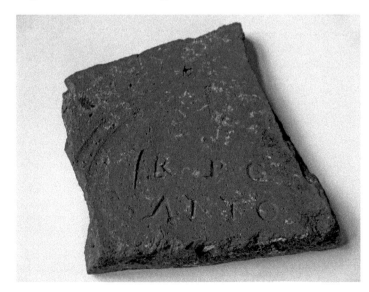

This Roman tile is stamped with the names of the Roman magistrates Julius Florius and Cornelius Similus, individuals who probably worked for the council. The Latin letters 'RPG' stand for *res publica glevum*.

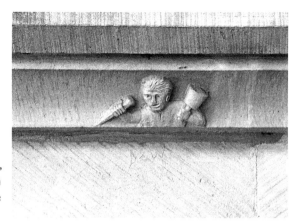

Hidden away in Gloucester Cathedral, a carving of a medieval stonemason at work, illustrating the tools of the trade, which have barely changed.

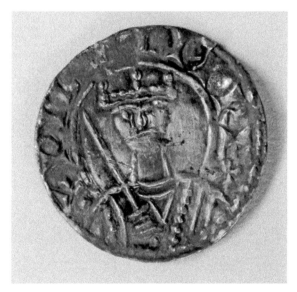

The Gloucester coin, minted by Silacwine between 1077 and 1080. It was found in 2011, north of the city.

Skilled coiners operated in Gloucester before the time of the Norman Conquest, when the city had its own mint. We even know some of the names of the coiners, as coins made here have been found with the place it was minted stamped upon it and the moneyer's name. One such person was Silacwine, who was a coiner operating shortly after the Norman Conquest. A coin minted by him was discovered recently, dated to between 1077 and 1080. This prestigious trade carried on until at least the thirteenth century as further coins bearing the place and name of the moneyer have been found; notable examples include a Henry I penny, c. 1123, coined by Esgar of Gloucester mint, and pennies from the reign of Henry III minted by such individuals as Lucas, Johan, Ricard and Rodger.

Tanning has been carried out in Gloucester since the early medieval period due to easy access to the River Twyver, which ran close to Hare Lane. Tanners' Hall, discovered when the inner relief road was being constructed, is thought to have been built in the early thirteenth century. There was a tannery listed in *Kelly's Directory* operating out of Lower Northgate Street until the 1930s.

Bellfounding has been a Gloucester industry for at least 700 years. The earliest reference is to a burgess called Hugh the Bellfounder in around 1270. An important late fifteenth-century

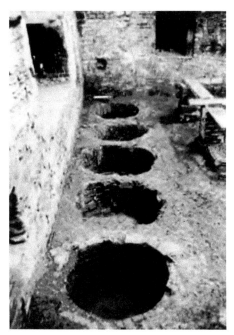

Left: The tanning pits, found during an excavation at the Tanners' House in Hare Lane when building the inner relief road.

Below: The mosaic in Southgate Street, outside the entrance to the Eastgate indoor shopping centre, citing the bellmaker William Henshawe and depicting the making of a bell.

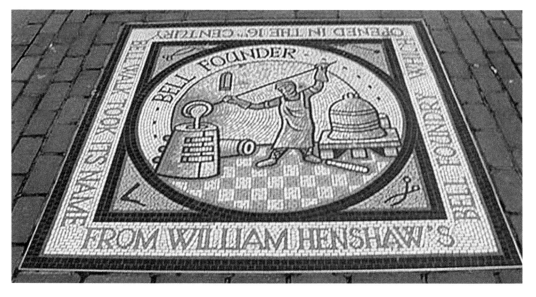

bellfounder was Robert Hendley, whose name appears on the fourth bell of St Nicholas' Church in Westgate Street. One of his successors, William Henshawe, was elected Mayor of Gloucester between 1503 and 1520. It is Henshawe's foundry that is believed to have given its name to Bell Lane – now Bell Walk in the Eastgate shopping precinct.

Abraham Rudhall developed a method of tuning bells by turning, rather than the traditional chipping method. He came to be described as the greatest bellfounder of his age. The business was passed down through the generations: first by his eldest son, also called Abraham, then Abraham's son Abel, and three of his sons, Thomas, Charles and finally John.

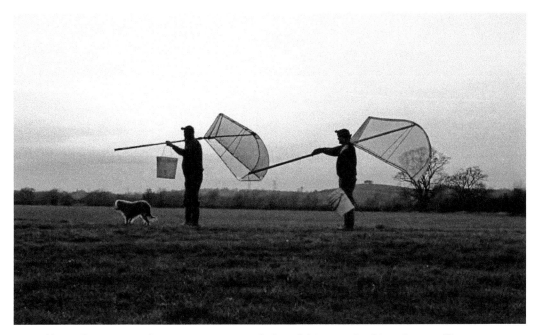

Above: Carrying on the ancient practice of elver fishing on the River Severn. These fishermen carry huge elver nets on their shoulders.

Below left: Working with salmon putts on the River Severn.

Below right: A local salmon fisherman, pictured with the prized Severn Estuary salmon catch.

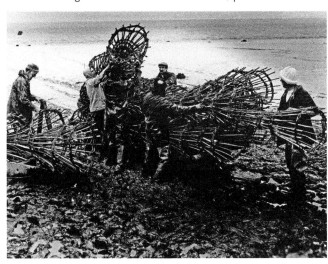

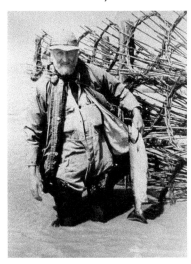

Gloucester is famous for the seasonal trades of elver and salmon fishing. Certain families and individuals have carried on this trade down the generations. The medieval methods of salmon fishing in the Severn Estuary is an ancient way of life, using the 'putcher rank' technique, and is still carried on today. In summer, wild salmon are caught in traditional nets in the River Severn.

Sir Thomas Bell the Elder was already a wealthy merchant when he invested much of his wealth in real estate released on the Dissolution of the Monasteries. He bought the former Blackfriars Priory and turned it into a cap-manufacturing business, spinning and knitting caps for headwear. He became one of the largest employers in the city, employing up to 300 people. On his purchase of Blackfriars in 1539, the antiquary John Leland remarked: 'The Blakefriers stood withe in the towne not far from the castle. This hows is by one Bell made a drapinge howse.'

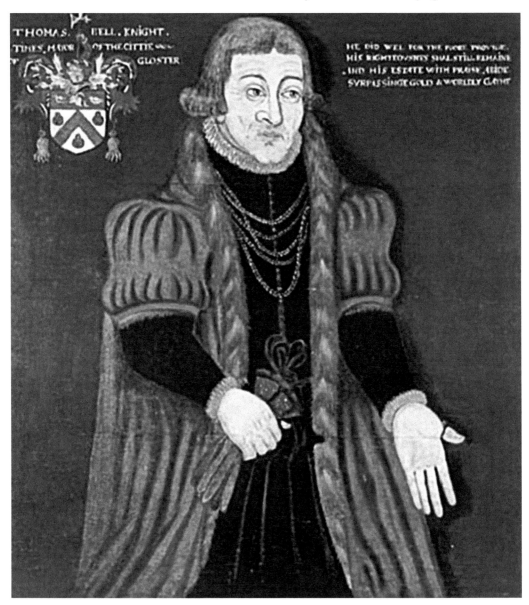

Sir Thomas Bell the Elder (1486–1566), Mayor of Gloucester. Oil on wooden panel. The writing to the top left reads: 'Thomas Bell, knight. 3 times Mayor of the Cittie of Gloster'. And to the top right: 'He did wel for the poore provide. His righteousness shal still remaine and his estate with praise abide surpassing gold & worldly gayne.' (Courtesy of Gloucester City Museum)

INDUSTRIAL REVOLUTION

The Industrial Revolution brought about large-scale change in the way people worked. People moved from rural areas to urban centres to work in the newly mechanised and factory-based methods of production. The Industrial Revolution in Gloucester was typified by the expansion of the pin-making industry. Before this time pin-making was largely carried out at home by outworkers. Although pin-makers and wire-drawers were working in Gloucester – such as John Tilsley, who set up a small factory near the South Gate and employed more than eighty 'boys and wenches' by 1632 – it wasn't until 1735 that pin-making was run on a large-scale industrial basis, employing thousands and heralding the start of the Industrial Revolution in Gloucester.

Price, Walker & Co. Ltd was started by Morgan Price in 1736, importing foreign timber from the Baltic. It was a family-run business, continued by his son William Philip Price. In 1840, Charles Walker joined the business. When the Gloucester & Sharpness Canal opened in 1827, the company expanded considerably.

In 1743, William Cowcher established a pin manufactory, operating out of buildings that now make up part of the Gloucester Life Museum in Westgate Street. This was to become Kirby, Beard & Co., which manufactured pins until 1853. Mechanisation on a large industrial scale was introduced. By 1763, it employed 1,200 men, women and children, and by 1802 there were nine pin factories in Gloucester, employing 1,500 workers out of a population of 7,579. The pin industry was revived in 1892 by the establishment of the Gloucester Pin Manufacturing Co.

The wine merchants Washbourn Brothers operated out of vaulted medieval cellars and bonded warehouses from 1767 to at least the early twentieth century. They exported wines and spirits to the USA, India, Australia, South Africa and Malta.

Since 1767 a firm of brush-makers called Ireland & Co. established itself in the city, at one time having premises in New Inn Lane. Brush-making was highly specialised, with each task being separated and carried out in separate rooms, including one called the 'pan' room. They manufactured brushes of all descriptions, including sweeping brooms, bass brooms, scrubbing brushes, hearth and banister brushes, stove, shoe and dandy brushes. The firm imported bristles from Russia, China, India and fibres from South America, Mexico and Africa.

The economic development of the city and surrounding region during the Industrial Revolution enhanced Gloucester's role as a banking centre. One of the first to be established

The Price works building, built in 1894 for Price, Walker & Co., still stands on Bristol Road.

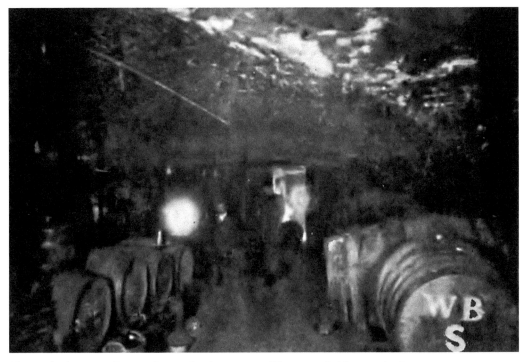

The vaulted wine cellars underneath what is now Gloucester's Masonic Lodge.

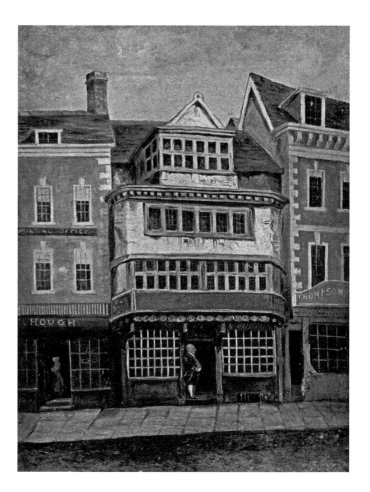

The premises of Gloucester Old Bank in Westgate Street, from an 1828 painting by J. R. Orton, with what appears to be the figure of Jemmy Wood in the doorway.

was the Gloucester Old Bank, which operated between 1716 and 1838. It was founded in 1716 by James 'Jemmy' Wood. The bank is reputed to be one of the oldest private banks in Britain, having survived the financial consequences of the Napoleonic Wars when many other banks went out of business. At some point in the nineteenth century, the bank became the Gloucester City Old Bank. In 1838, it was taken over by the County of Gloucestershire Banking Co., which eventually became part of Lloyds Bank.

Nibletts' Old Bank was established in the 1790s by the partnership of James Jelf, William Fendall (a barrister) and Charles Evans (an attorney).

John Turner ran a private bank in partnership with members of the Jeynes and Morris families, later to become the Turner & Morris Bank. Other private banks were the Gloucester Bank, run by Merrot Stephens, which failed during the banking crisis of 1815. Other notable bankers were Robert Pleydell Wilton, Thomas Washbourne and Thomas Russell, who later became Russell & Skey. The business of Russell & Skey was absorbed into the Gloucestershire Banking Co., and in 1834 the National Provincial Bank opened a branch in Gloucester – its first in the province.

J. M. Butt & Co. were one of the oldest ironfounders in the city. Their ironworks were situated in the Kingsholm area, around Columbia Street and Sweetbriar Street. In 1864, an accident at the factory left two workers, Jesse Davis and George Witts, badly burned. In 1917, the foundry was sold to Messrs Danks Ltd of Westgate Ironworks in Gloucester.

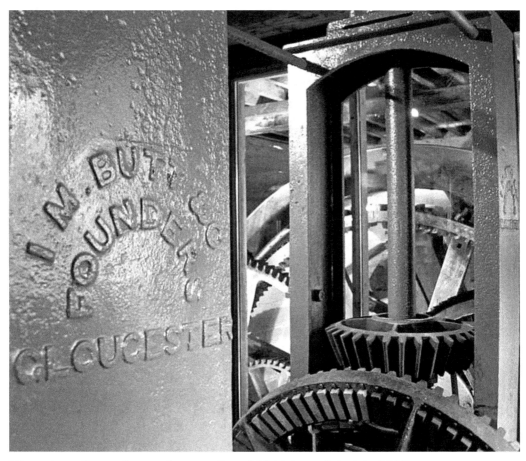

Water-driven flour-milling machinery at Egypt Mill, Nailsworth, built by J. M. Butt.

J. M. Butt's products appeared nationwide. It is said that this is one of the oldest postboxes manufactured by J. M. Butt. It still stands somewhere in Sherborne, rural Dorset.

VICTORIAN AGE

Trade along the River Severn had gone on for centuries, but it wasn't until the opening of the Gloucester & Berkeley Canal in 1827 that trade flourished on an industrial scale, which gave the city a major role in seagoing trade and laid the basis for its commercial and industrial expansion in the Victorian era. The transformation of the dock area between 1835 and 1850 is illustrated in the image here.

The engineering industry also experienced massive growth. By 1891, there were 7,185 people employed in the metalworking industry, and by the end of the Victorian era it had risen to 9,490.

Kell, Meats & Co. was founded to design and manufacture agricultural implements and machines, beginning life in Ross-on-Wye. The company moved to Gloucester in 1904 and occupied the Vulcan Works in Quay Street, expanding into subcontract machining and non-ferrous casting and becoming Kell & Co. Ltd.

Some years later, a cement chemist named William Fennell began experimenting with Holpebs (hollow pebbles), using tubular steel bodies to improve the fine-grinding process in cement mills. Following a period of research and development, Helipebs (helical pebbles) were introduced. William Fennell joined forces in 1915 with Robert McDougall, who worked in the cement industry, and they began working for the British Carbonising Co. in Gloucester, who at that time were making steel tyre studs for the Ministry of Munitions as well as Helipebs.

In 1922, Helipebs Ltd was formed, taking over the British Carbonising Co. In 1956, the original site in Quay Street (formerly occupied by Cotton Motorcycles) was purchased. The company also acquired Kell & Co. Ltd. The company prospered, supplying many local firms including Fielding & Platt, Gloster Aircraft Co., Bryce Berger and Rank Xerox. To this day, the company has Geoff Davis at its helm, the grandson of its founder, Robert McDougall.

In 1969, Helipebs Controls Ltd was founded and soon after moved to their current premises in Sisson Road, Gloucester, occupying the former foundry on that site.

In 1838, Jesse Sessions established a timber, slate and building materials merchants, along with the manufacturing business Sessions & Sons Ltd. They dressed imported slate to look like marble, granite, or wood and invented a new manufacturing process known as 'Miller's Plate'. They also patented Compoboard, or matchboard, which was a substitute for lathe and plaster. It was one of the largest manufacturers of enamelled slate in Gloucester, covering several acres of land. It supplied the thousands of tons of cement needed to build Gloucester's electric tramway system.

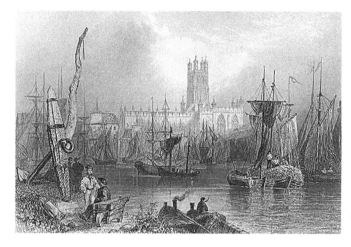

An engraving of the busy docks area in 1835.

An ancient winnowing machine by Kell Meats & Co., Gloucester.

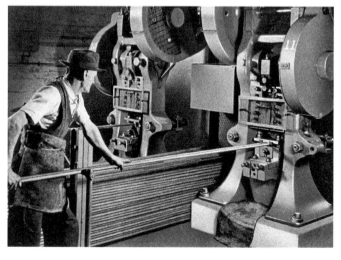

Albert Davies cropping slugoids used in cement grinding at Helipebs Quay Street site, 1950s.

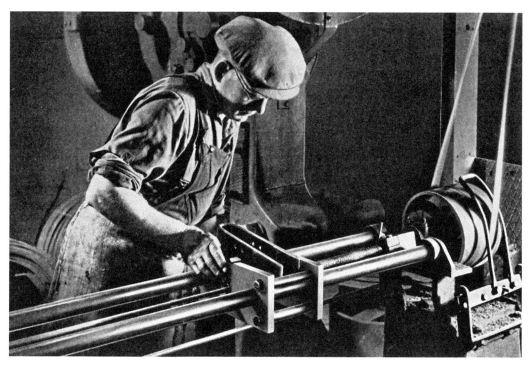

Bert Smith coiling Helipebs used in cement grinding at Helipebs.

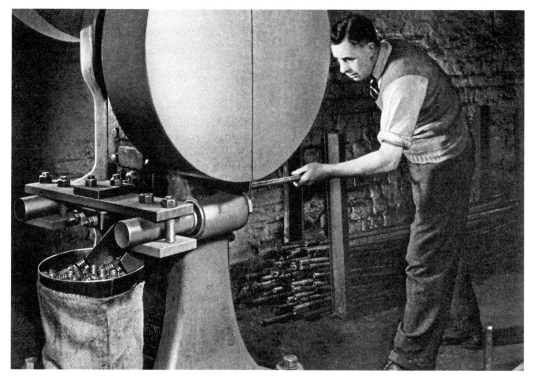

Bert Nicholls cropping Helipebs.

Left: Robert McDougall, the company's founder.

Below: Ron Brittle, John Poulton, John Lindsey and Chris working capstan lathes at the Machine Shop, 1970s.

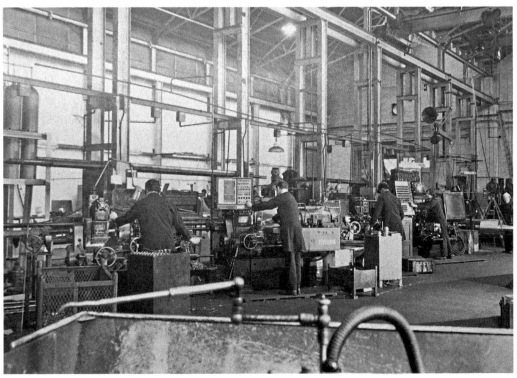

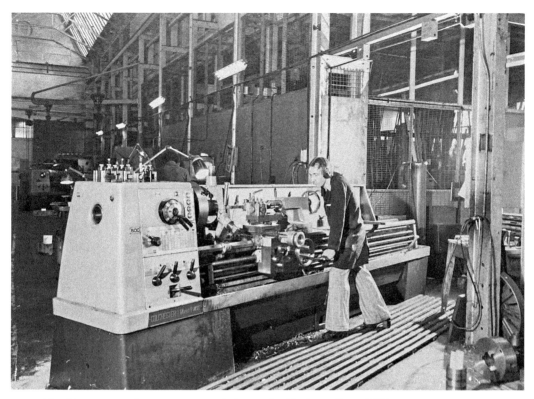

Alan Hopson working on a centre lathe in the Machine Shop, 1970s.

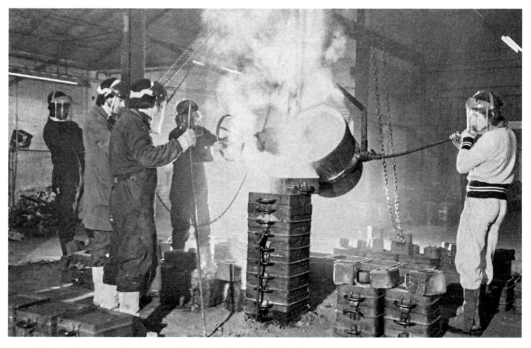

Pouring hot metal into a mould at the foundry, 1970s. Note the improvements in protective clothing.

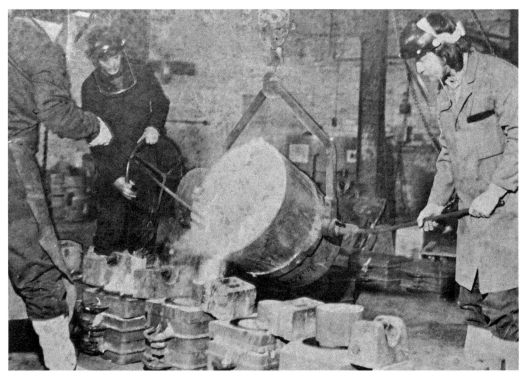

Bob McKenzie and Ray Cocksedge pouring hot metal into a mould at the foundry, 1970s.

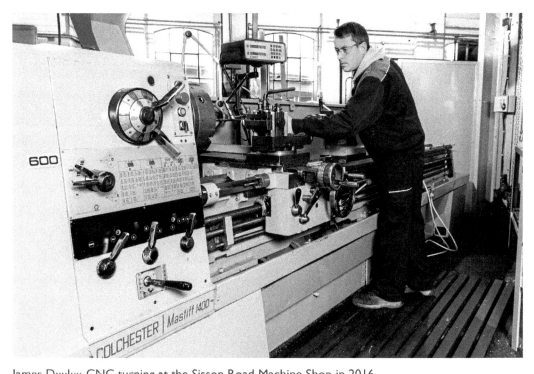

James Denley, CNC turning at the Sisson Road Machine Shop in 2016.

By 1897, they had built a factory at Baker's Quay for the manufacture of chimney pieces and bathroom furniture. Most of Gloucester's enamelled slate production ceased before 1918.

In 1839, the year of Sir Robert Peel's Constabulary Act, which allowed counties to set up police forces paid out of local rates, Gloucester had its own police force. The first WPC, Marion Sandover, joined Gloucestershire Constabulary on 1 July 1919 with the collar number of WPC1.

Priday, Metford & Co. was founded by Charles Priday, Mr Francis Killigrew, Seymour Metford, and Mr Francis Tring Pearce, who had been a partner in the firm of Reynolds and Allen.

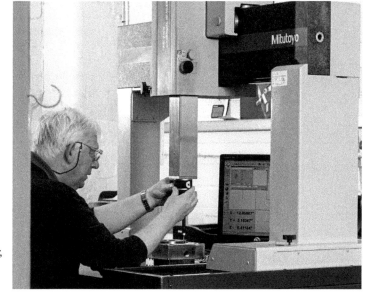

Right: Nigel Bird inspecting finished components on a co-ordinate measuring machine at the Sisson Road Machine Shop in 2016.

Below: Marion Sandover, sitting furthest right in police uniform.

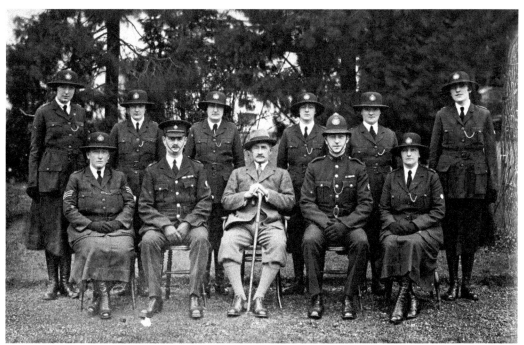

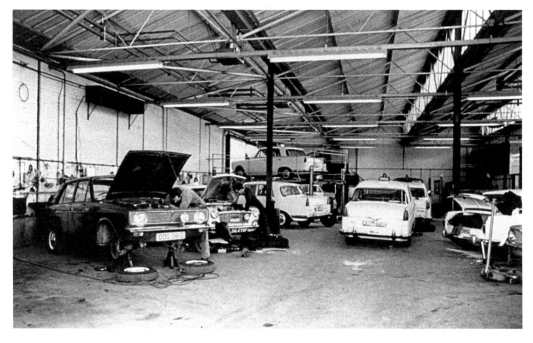

Above: Police Vehicle Workshops at Cole Avenue, Gloucester. This image shows staff working on Austin Westminster Patrol cars, Austin 1100 Panda cars and Hillman Minx cars (Criminal Investigation Department) in 1960.

Left: Mrs Pat Stanton, supervisor at the Central Ticket Office in Barton Street, 1980s.

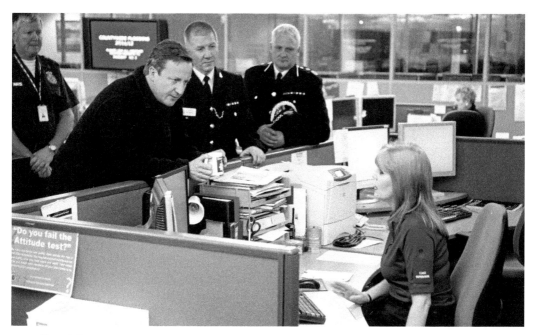

David Cameron, then prime minister, visiting staff at the Tri-Service Control Room during the 2007 floods talking to Force Control Room supervisor Ginny Maslin. Also in the photograph is Superintendent Gary Thompson.

Frank Pearce (b1857) Cecil Booth Margaret Winnifred Pearce (b1882) Hugh P Vowles Helen Pearce Oscar Pearce (b1885)
Agnes PearceLottie Pearce Francis Tring Pearce (1846-1935) Martha Pearce nee Allen (1846-1920) Henry Pearce, Minnie (nee Vowles), Herbert Pearce b 1880
Pearce family of Priday Metford Limited, Gloucester, probably taken at Lorraine House, Park Road, Gloucester, England

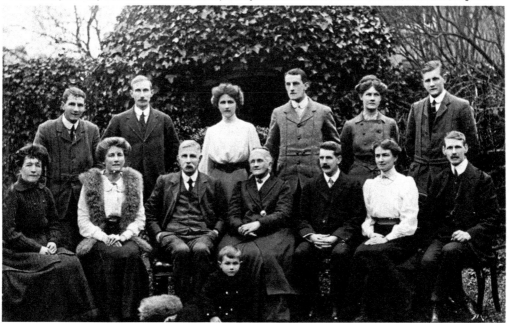

Members of the Pearce family, who were part-owners of Priday, Metford & Co.

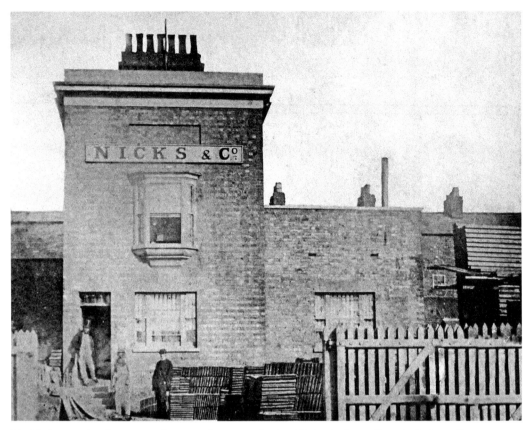

Mr Nicks, resplendent in top hat, standing outside the Nicks timber offices in Bakers Quay.

The flour they produced had names such as Leathertie, Bluetie, Extras, Whites and Imperials. Before the First World War, the company had its own horses, which were stabled at the mill and used to pull the drays. Until the 1970s, the company used barges, some of which it owned through a subsidiary, Fox Elms Ltd.

Nicks & Co. was formed in 1840 from an alliance between Thomas Wyatt Baxter and William Nicks, and is still trading today. The firm of Nicks & Co. has been importing timber through Gloucester for more than 150 years and can claim to be Gloucester's longest established independent business. Founded by William Nicks, it has remained essentially a family concern through five generations.

They initially operated from premises on Bakers Quay, but moved to their current premises at Canada Wharf in 1870, building their own sawing, planing and moulding mill, with the steam engine being fuelled by waste wood and cooled by water from the canal. A creosoting work for preserving wood for railway bridges, sleepers, sheds, fencing and woodblocks was also built, the creosote originally being supplied by William Butler's tar-distilling plant on the riverbank at Sandhurst.

The outbreak of the First World War had a serious effect on the timber trade because much of the traffic from the Baltic was cut off, which soon led to financial difficulties for the partners. The firm survived, however, thanks to help from Frank Croxford, managing director of Price Walker & Co., the principal timber merchants in Gloucester. It seems that Croxford was happy for Nicks & Co. to continue to supply smaller customers while Price Walkers concentrated

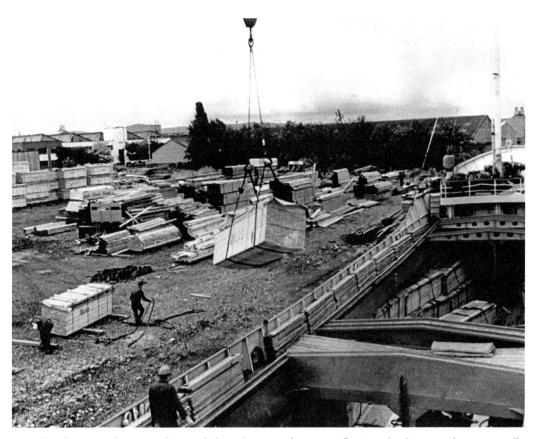

Loading wood onto a ship or lighter by use of a crane. Previously, this was done manually and needed two men to lift the deals (planks of wood) onto another man's shoulder before loading onto the ship.

on the larger businesses. He also loaned them enough money to keep Nicks & Co. going – not something that would happen today. Croxford introduced a new partner, Thomas Lawrence Drury. Drury brought with him substantial business, including the supply of wood for packing cases to firms like Guest Keen & Nettlefolds of Birmingham. Thanks to the loan from Frank Croxford, the new management built a capacious new shed adjoining the south side of the mill in 1916 for storing the better classes of timber under cover.

However, even after the war was over, trading conditions remained difficult, and Nicks & Co.'s imports were only around a third of the level before the war, mainly coming from the Baltic and Scandanavian countries. A surviving agreement between the employers and the Dock Wharf Riverside and General Workers Union shows that the working hours in the timber yard on weekdays were 6 a.m. to 5 p.m. in summer (7 a.m. start in winter), and 12 noon finish on Saturdays. There were breaks of ninety minutes for breakfast, sixty minutes for lunch, and thirty minutes for bait each morning and afternoon. Piecework pay rates were agreed for men discharging lighters (boats) and carrying deals (planks of wood) to piles in the yard, with additional money for carrying more than 80 yards, and daywork rates were agreed for taking wood from piles for dispatch. The height of the piles was not to exceed eighty 3-inch deals or equivalent (20 feet) in order to limit the height of the lines of planks supported by trestles, along which the men ran when carrying the wood to pile.

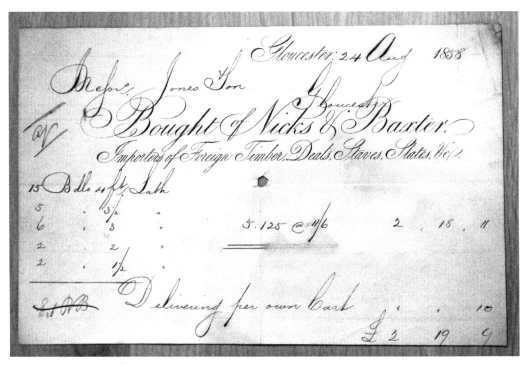

An invoice dated 1858, with the words 'delivering from own boat'.

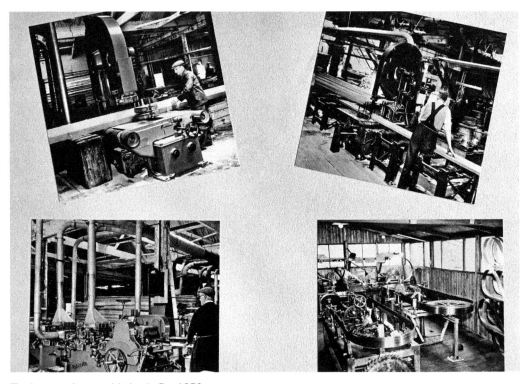

Timber workers at Nicks & Co., 1952.

In 1929, Lawrence Buchanan died. Following his death, Buchanan's family wanted to withdraw their financial interest in Nicks & Co., but Tom Drury managed to find sufficient finance to pay them off, leaving him as the sole proprietor until his son Thomas Robert Drury joined him a few years later.

After the Second World War, senior partner Thomas Drury died in August 1955, leaving the business to be carried on by his sons Tom, John and Kenneth. In January 1960, the three brothers converted the business into a private limited company, and a year later they purchased the freehold of Canada Wharf. This paved the way for them to upgrade the mill, including replacing their steam engine by electric power in 1963.

The 1960s was a time of great change in the timber trade, particularly due to the new practice of packaging timber in the country of origin and the use of machines for handling timber in the yard. Tom Drury and his son Chris toured the Baltic ports to persuade suppliers to package their timber, which they arranged to be shipped in coasters that could deliver directly to Canada Wharf. By this time, the management of Nicks & Co. had passed to Chris Drury and his cousin Tony Drury.

After much hard work, the business was beginning to prosper again, that is until trading conditions became difficult due to the recession in the 1990s. To reduce their borrowings, the Drury cousins decided to sell off the northern half of Canada Wharf as by that time they did not need as much storage space because the atomic-powered ice breakers kept the Baltic open throughout the winter, and most of the timber was kiln dried in the country of origin. Chris Drury still works for the company.

William Eassie moved to Gloucester in 1849 to work on the Gloucester & Dean Forest Railway. By 1851, he had set up William Eassie & Company, a steam-powered saw mill on land at Madleaze, beside the Gloucester & Sharpness Canal. They built the crushing machine installed in Provender Mill for Foster Brothers.

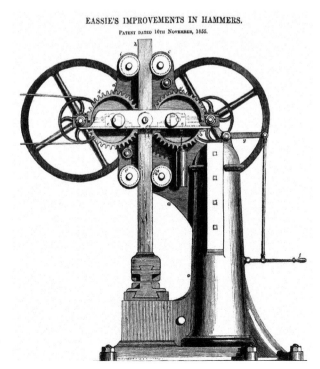

Eassie's improvements in industrial hammers, patented 1855.

W. EASSIE & CO.,

Railway Saw Mills, Moulding Shops, &c.,

AND GENERAL TIMBER CONVERTING YARDS,

HIGH ORCHARD, GLOUCESTER,

(London Office, 18, GREAT GEORGE STREET, WESTMINSTER, S.W.),

Are Prepared to Furnish Quotations for any Description of

WOOD FITTINGS,

For Home or Foreign Railway Stations, Barracks, Exhibitions, Dwellings, Warehouses, Factories, Stores, Glasshouses, &c.

They will also Contract for Wooden Fittings of any kind, in connection with Iron Buildings, &c.

The above would in all cases be consigned ready fitted, so as to insure speedy re-erection.

Numerous drawings of works of the above nature, already executed, can be seen on application, and references permitted to the Engineers thereof.

The above Firm supply Barrows, Carts, Wagons, temporary Huts, permanent Shedding, and every description of Miners' and Contractors' Tools, at the very lowest prices. References can be given where many thousands of the above have been supplied to different parts of the world. Prices quoted on application. Delivered to any station, or home or foreign port.

ALSO,

Patent Self-Acting Steam Pile Driver,

A VAST IMPROVEMENT ON ALL EXISTING ONES,

Can be seen working at our yards at Gloucester, and a model of the action at our Office, 18, Great George Street, Westminster.

A poster advertising Eassie's Wood Fittings and introducing the patented self-acting steam-powered pile driver.

PATENT STEAM PILE DRIVERS,

Perfectly Self-Acting.

Adopted by the Admiralty, &c., and largely used at home and abroad.

A Telescopic Engine of this patent for Trench work is also made. A spring is introduced in the monkey of these Engines.

STEAM CRABS,

SIDE AND END-TIP WAGONS,

DOBBIN CARTS,

Wheelbarrows, Hoists,

Navigators' Huts, Wooden Houses,

And every kind of Contractors and Builders' requirements supplied.—Manufactured solely by

W. EASSIE AND CO.,

Limited,

HIGH ORCHARD WORKS

GLOUCESTER.

London office, 18, Great George-street, Westminster, S.W.

Drawings and prices of the above, with terms for sale or hire, may be had on application. K1382

PRIZE MEDAL Awarded PARIS, 1867.

Patented steam pile drivers, which were awarded the Prize Medal in Paris in 1867.

The Gloucester Wagon Co. was established in 1860. By 1888, it was re-registered as Gloucester Railway Carriage & Wagon Co. (GRWC). They were primarily a railway rolling stock manufacturer based at Bristol Road. They had been building bodies since the horse-drawn days and would do so until their demise in 1986.

The company was formed at a meeting on 30 January 1860 with an initial capital of £100,000 in 10,000 shares of £10 each. The first general manager was Isaac Slater, whose name appears on adverts dating from 1874.

A work was established in 1860, producing over 300 wagons in the first year. Through the latter part of the nineteenth century, the company manufactured wagons and carriages and

GLOUCESTER WAGON CO.

LIMITED,

MANUFACTURERS OF ALL DESCRIPTIONS OF

RAILWAY CARRIAGES, WAGONS,

AND

IRONWORK.

This Company has a large number of Wagon Repairing Stations, where repairs can be promptly executed.

APPLY TO THE MANAGER AT GLOUCESTER.

LONDON: 26, Parliament Street, S.W.

MANAGER: Isaac Slater.

(21-z)-48.

An advert for the Gloucester Wagon Co. dating from 1874, extolling their extensive manufacture of railway carriages, wagons and ironwork. Isaac Slater's name, the company's first general manager, appears on the advert.

received orders from around the world, sometimes for the strangest and most innovative of vehicles. During the Boer War, the company manufactured horse-drawn ambulances. Their products included goods wagons, passenger coaches, diesel multiple units, electric multiple units and various special-purpose vehicles. The company supplied the original fleet of red trains for the Toronto subway, which were based upon similar vehicles to the London Underground. At the outbreak of the First World War in 1914, they employed 1,900 people and produced stretchers, ambulances, shells and wagons.

The company also produced pivoting sections for Mulberry harbours for the British War Office, which were temporary portable harbours developed during the Second World War to facilitate the rapid offloading of cargo onto beaches during the Allied invasion of Normandy in June 1944. They also produced tank-carrying wagons, shells, and other parts and equipment. By 1941, the company began producing Churchill tanks, eventually making 764 units by 1945. By 1961, the company was still manufacturing railway rolling stock, employing 1,250 when it was taken over by Winget of Rochester, Kent. The last carriage was made in 1963 and the last complete wagon in 1968. In 1989, the extensive, but now redundant, offices in Bristol Road were demolished to make way for what is now the Peel Centre. The only GRCW building left on site is the former carriage-building shop, now home to JDR Karting.

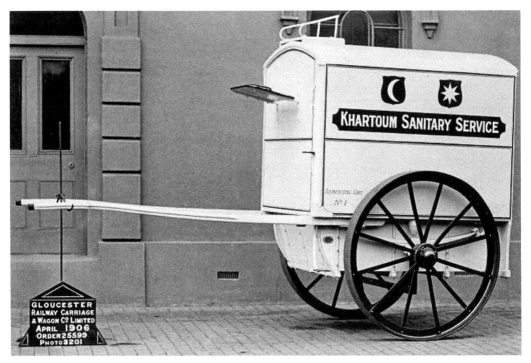

The Khartoum Disinfecting Cart No. 1, manufactured by Gloucester Railway Carriage & Wagon Co. in 1906.

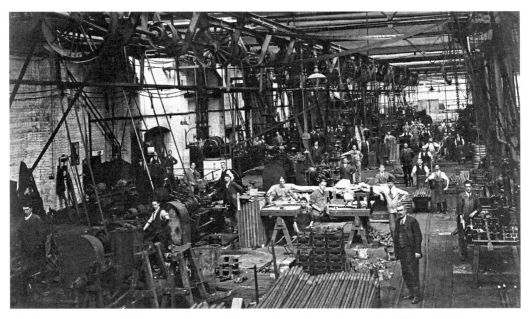

Workers on a crowded factory floor in the metal machine shop at the Wagon Works on Bristol Road, Gloucester, manufacturing parts for use on wagons. The machinery in the foreground are possibly metalworking lathes for turning/machining metal into usable parts given the metal rods on the floor.

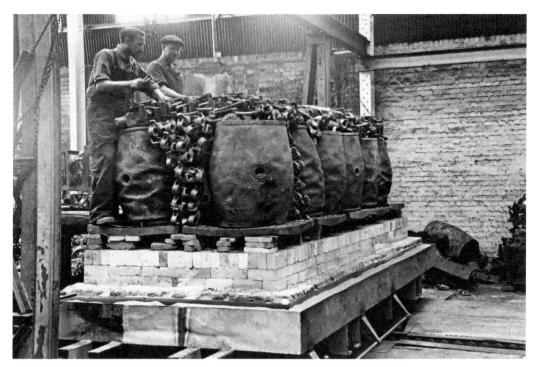

Two workers next to a collection of hessian sacks possibly in the Wagon Works on Bristol Road, Gloucester – either checking stock or looking for components for a wagon/carriage.

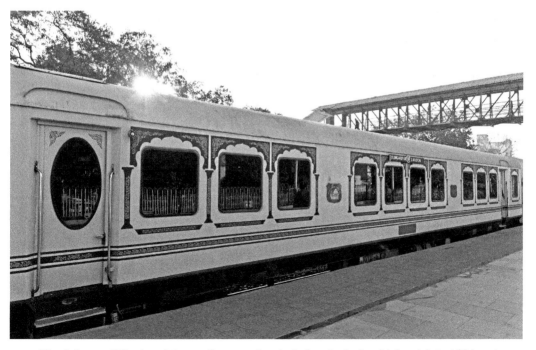

The *Palace on Wheels* at Jaipur railway station, built for the Indian Maharajah in 1936 and now operated by Indian Railways as a tourist train.

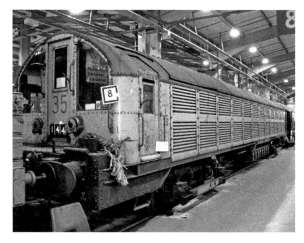

London Underground battery-electric locomotive L35, built in 1938 by the GRWC. It remained in service until 1993.

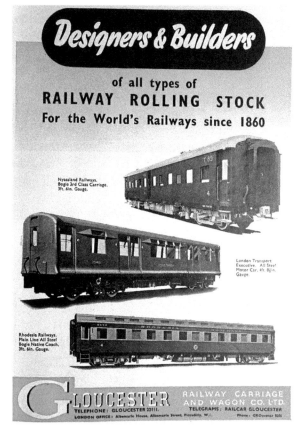

An advert from 1954, promoting the company as designers and builders of all types of railway rolling stock since 1860.

Thomas Nelson Foster and his brother Richard Gibbs Foster established Foster Brothers, an oil seed-crushing mill on Bakers Quay in 1862. The brothers imported 800 tons of seed a week from Egypt, India, Russia and Argentina to make linseed cake, feeding oilcake, decorticated (where the husk is removed) cotton cake, and food for sheep and lambs. In 1895, the company became a branch of British Oil & Cake Mills Ltd (BOCM). The mill continued to be managed by three generations of the Foster family until 1945.

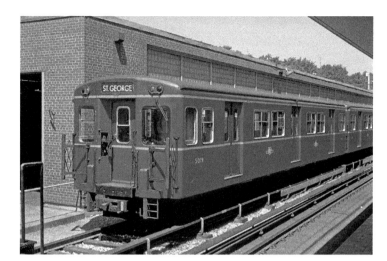

A Gloucester
(G-series) subway
car that operated
in Toronto, Canada,
c. 1969.

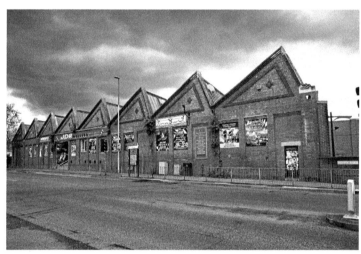

Part of the vast
complex of buildings
that made up
Gloucester Railway
Carriage & Wagon Co.,
now a karting venue
on Bristol Road.

Antiquated machinery
in the former mill,
built by Eassie & Co.
for Foster Brothers
(BOCM). The mill
later became known
as Provender Mill.
Destroyed by fire in
2015, it is now being
renovated as part of
a mixed development.

Inside Provender Mill (formerly BOCM) before the disastrous fire. The image shows an old shute that was used to transport grain inside the mill.

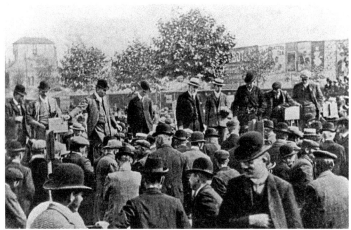

Barton Fair in 1905. H. W. Bruton can be seen standing here with the long grey beard.

A group photograph of auctioneers at Gloucester Cattle Market in 1962.

Bruton Knowles has an incredible family and partnership history, rising from humble beginnings and overcoming adversity to become a national property consultancy brand. Established in 1862, Bruton Knowles celebrated its sesquicentennial (150-year) anniversary in 2012. They are auctioneers, estate and house agents, and land surveyors.

In 1863, J. A. Matthews, who was born in Gloucester, purchased a small furniture business, Matthews & Company, at the corner of Southgate and Parliament Street. Matthews invented and patented over 150 furniture specialities, or designs, which were made at the premises. The furniture was mass-produced at their purpose-built factory on the docks. The company manufactured the bookcases used to promote *Encyclopaedia Brittanica*. Their furniture is now very sought after and collectable.

Fielding & Platt were a world-renowned company and one of Gloucester's greatest engineering firms, operating from their Atlas Works from 1866 to 2003, when it finally closed. It pioneered the manufacture of hydraulic machinery, produced Britain's first vacuum cleaner in 1902 and in 1963 produced the aluminium plate stretcher that helped to build Concorde.

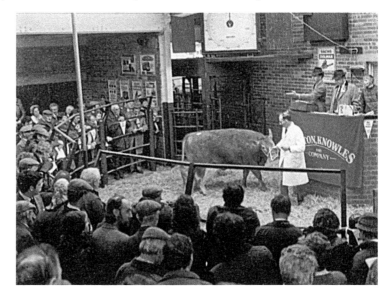

The cattle market where Bruton Knowles held regular auctions in the 1980s.

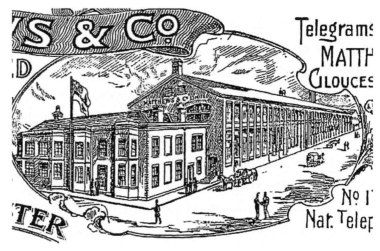

An engraving of the Matthews furniture factory dated 1904. The building in the foreground is now Bill's restaurant.

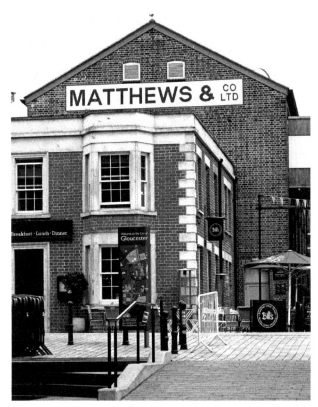

Left: A painted sign is all that is left of the Matthews furniture factory at the docks. As you can see, the building in the foreground is now Bill's restaurant, part of the redeveloped docks area.

Below: The former Matthews furniture factory in Parliament Street, now the Gloucester Warehouse Climbing & Caving Centre.

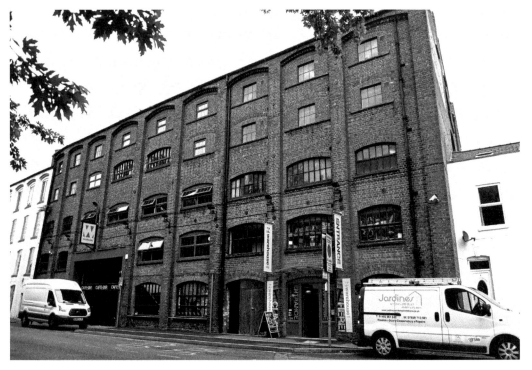

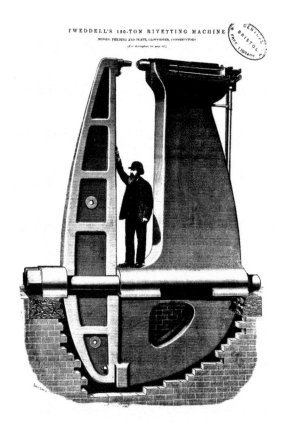

Right: Tweddell's 150-ton rivetting machine, made by Fielding and Platt, drawn to scale and showing the sheer size of construction, 1885.

Below: An engraving of a 30-horsepower 'Fielding' gas engine dated 1893.

CONSTRUCTED BY MESSRS. FIELDING AND PLATT, ENGINEERS, GLOUCESTER

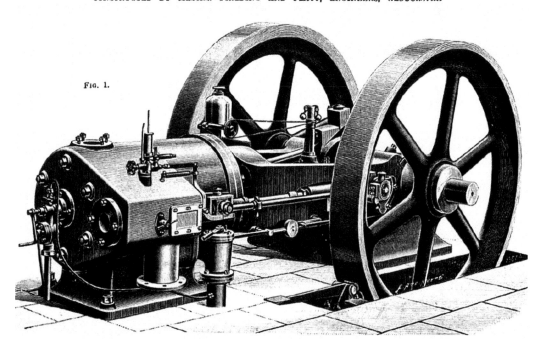

FIG. 1.

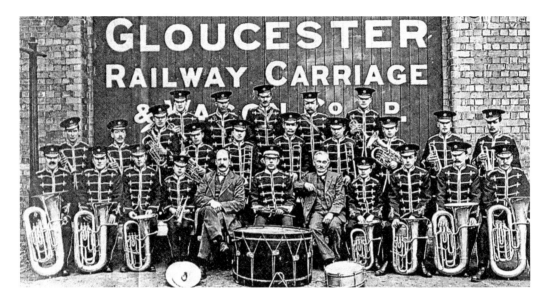

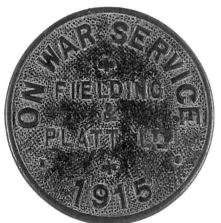

Above: Gloucester Railway Carriage & Wagon Co. Band, 1916.

Left: A war token from Fielding & Platt dated 1915.

S. J. Moreland & Sons was set up by S. J. Moreland in 1867. It was a family business that operated out of huge premises on Bristol Road, manufacturing Safety, Paraffin, Vesuvian and Wax matches. Known for manufacturing the famous England's Glory matches, they employed around 1,000 workers in the early twentieth century.

J. Reynolds & Co. Ltd was established by James Reynolds in 1869. By 1882, they were the first flour-milling company in Gloucester to install a complete roller system. Their wholemeal flour was endorsed by none other than Thomas Richard Allinson, the famous British doctor, dietetic reformer, businessman and journalist whose name is still used on bread products today.

In 1870, John Stephens established a vinegar and pickle factory in St Catherine's Street. In December 1896, he ordered a covered horse-drawn van from the Gloucester Wagon Co. and the business traded as John Stephens, Son & Co. In 1901, they were described as 'purveyors, manufacturers, packers, bottlers, and manufacturers of or dealers in pickles, jams, marmalade, fruits, sauces, soup, jellies, food stuffs, provisions, confectionery etc.'

The Severn & Canal Carrying Shipping & Steam Towing Co. was formed in 1873 to transport goods along the canal. Those working on the boats became a close community.

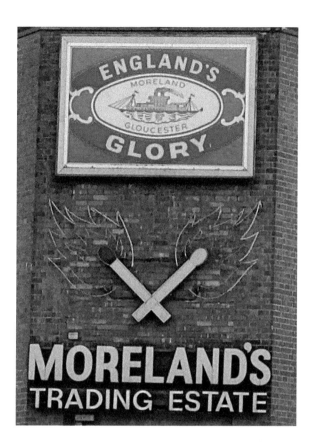

Right: The iconic England's Glory sign on the premises of the Bristol Road Match Manufactory of S. J. Moreland & Sons.

Below: An advert for Moreland's matches, placed in 1955.

S. J. Moreland & Sons Ltd.

Match Manufacturers
and
Timber Importers

"England's Glory" Match Works
Bristol Road - GLOUCESTER

Tel : 22186 & 22187 Grams : "Matches, Gloucester"

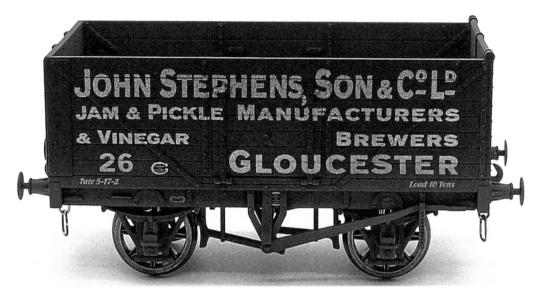

John Stephens ordered two 10-ton, 7-plank open coal wagons, including No. 26, in November 1901 from the Gloucester Railway Carriage & Wagon Co. Ltd, presumably to bring coal from Eastern United Colliery in the Forest of Dean to power the boilers at the Vinegar Works. Each wagon cost £58 10s and a repair contract was taken out at the same time and renewed in 1908.

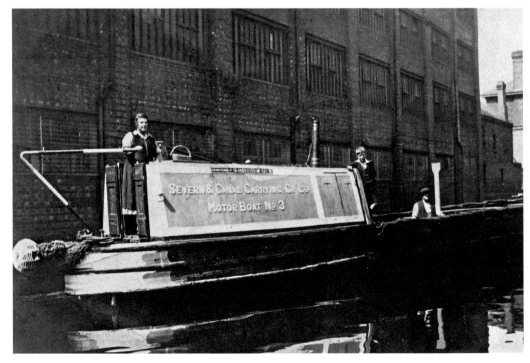

Registered at Gloucester, bearing the number 621, this was Motor Boat No. 3 of the Severn & Canal Carrying Shipping & Steam Towing Company.

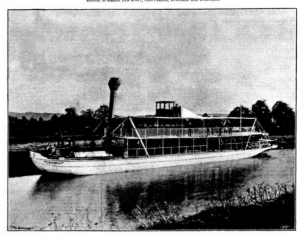

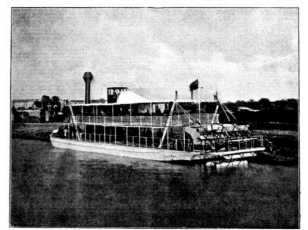

Isabel, a stern-wheel steamer
boat for river use, built in 1892
by Summers & Scott Ltd.

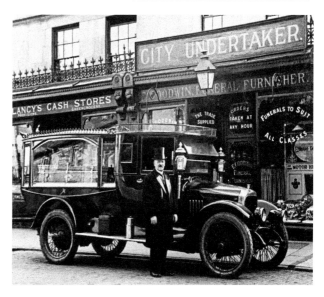

A member of the Goodwin
family seen outside their
premises in Barton Street
c. 1920.

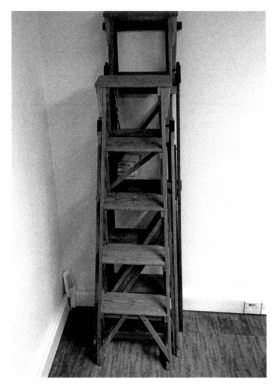

A set of Lattisteps, part of a prized collection of Frank Norville's of the Norville Group Ltd.

Summers & Scott Ltd was established in 1881. They were an innovative engineering company, building, among other things, linoleum-making machinery and light draught steam tugs and launches. They operated out of High Orchard Ironworks, Gloucester.

Goodwins Funeral Directors are a family business, having occupied premises in Barton Street since 1883. Bob Goodwin, who passed away in 1984, aged eighty-four, was actively involved in the business that he established right up until his death.

By the early twentieth century, the Hatherley Step Works was the largest step works manufacturer in the world. The works covered an area of 2.5 miles. In 1885 its founder, Charles Allan Jones, began to manufacture stepladders, which he patented. They became so well known that they were called 'Lattisteps'. The company were still making stepladders and cabinets at the Hatherley Works site until the1950s.

In 1889, William Sisson established W. Sissons & Company Limited, engineering and building high-speed steam engines. All types of steam machinery, including high- and low-speed enclosed engines were designed and manufactured. They also specialised in the design and development of high-speed launch and marine engines and boilers, and designed vessels that were used on the rivers Thames and Severn and Lake Windermere. The company closed in 1968 with a loss of 160 jobs.

In 1892, Harry Owen Roberts set up Roberts Brothers with his brother John Owen Roberts. They operated out of their Glevum Works in Upton Street, manufacturing games such as Piladex.

F. J. Cambridge & Co. was established in 1893 by Frederick John Cambridge. In 1900, the business moved to its current site on Stroud Road. The company has remained a family business and still has three generations working within it.

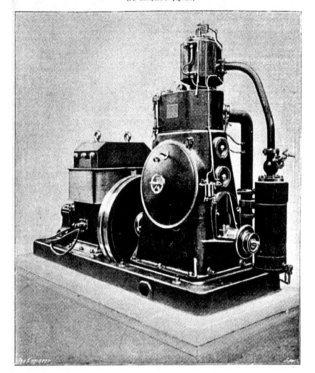

HIGH-SPEED VERTICAL COMPOUND ENGINE

WILLIAM SISSON, GLOUCESTER, ENGINEER

(For description see page 291)

The company designed and manufactured a large variety of steam engines and related plant. They also specialised in design and manufacture to customers' own requirements. This image shows an early experimental steam engine designed by Sissons in 1914.

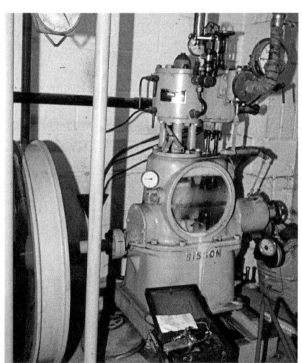

An example of a slow-speed engine, primarily used to power ships, designed by Sissons.

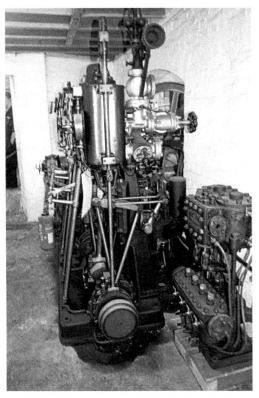

Left: A steam engine designed by Sissons.

Below: Possibly an air compressor, designed by Sissons.

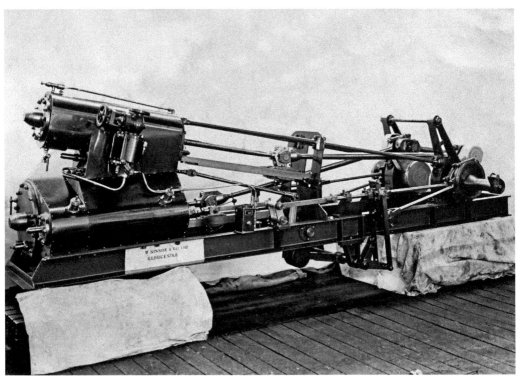

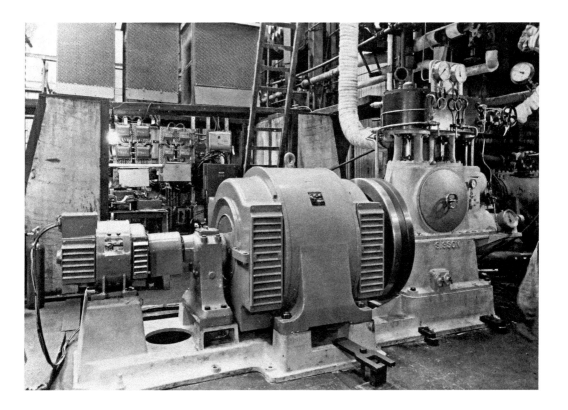

Above: One of Sisson's larger machines, possibly a high-speed vertical compound engine.

Right: The American version of Piladex, franchised in 1896 as Pillow Dex and produced in the US by Parker Brothers based on the game invented and manufactured by the Foster brothers in Gloucester.

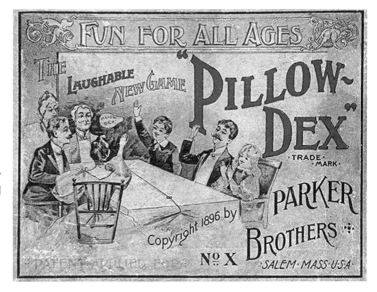

In 1884 a conference was held in Gloucester, after which a model dairy was established in Longsmith Street, called Gloucester Dairy. In 1896, this was taken over by the Gloucester Dairy Supply Co. The dairy produced well-known cheeses such as Little Gloucesters, Glevum and Gloucester Cheeselets as well as clotted cream, butter and sterilised milk.

Working on a stone portico, c. 1950.

Dennis Cambridge, working on the public memorial of Robert Raikes in Gloucester Park.

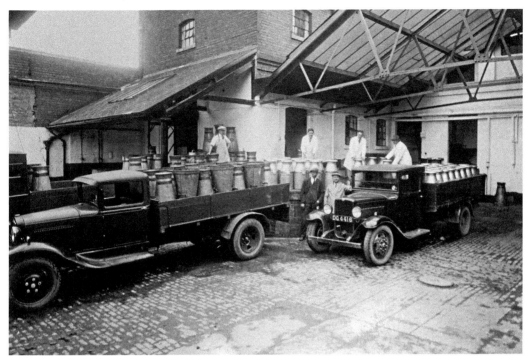

The dairy premises in Longsmith Street, Gloucester.

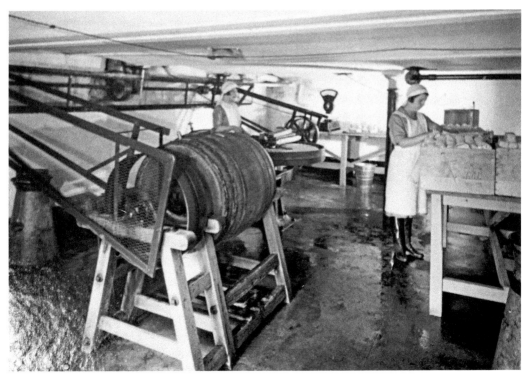

Butter churning in a wooden barrel with female workers making it into butter packs.

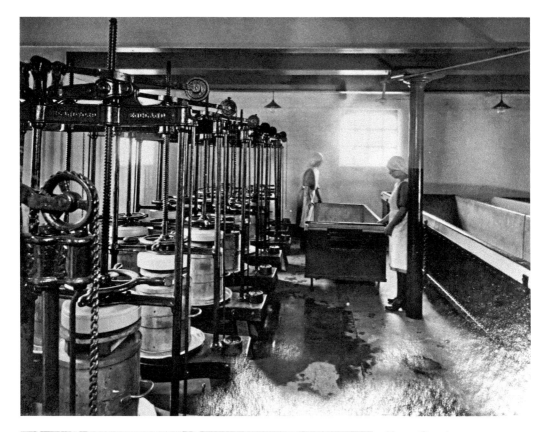

Above: Cast-iron cheese presses, with the enormous whey vats to the right of the picture.

Left: An office worker from Turner, Nott & Co. Ltd in the former Lucy warehouse on Commercial Road in the early 1900s.

Turner, Nott & Co. Ltd were corn merchants who imported foreign grain from all over the world. They also manufactured a product called dredge – a food for cattle and horses.

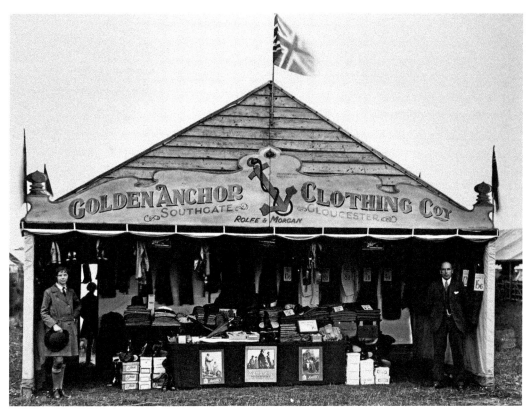

The Golden Anchor stall, possibly at the Royal Agricultural Show in Oxleaze, Gloucester, in 1909.

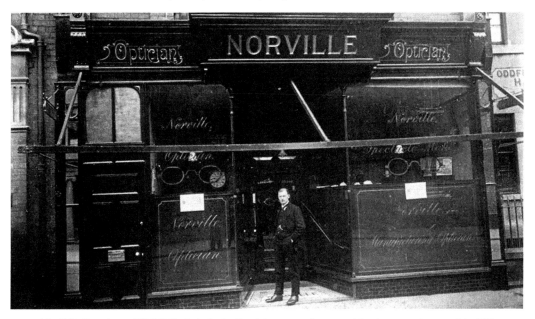

Mr F. E. Goodwin, FSMC Ophthalmic Optician, standing outside the premises at No. 7 Barton Street in the 1920s.

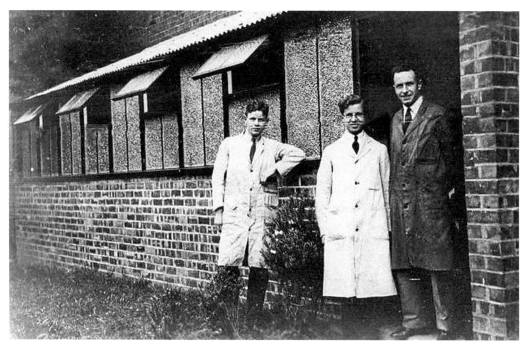

The workshop team in the garden of No. 7 Barton Street in 1925.

Workers building the Magdala Road premises in 1935.

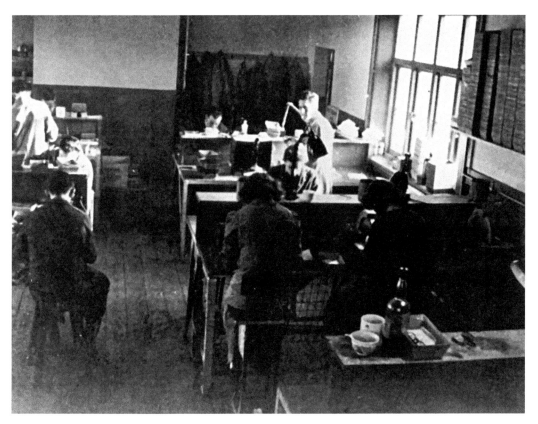

Above: Workers at the Russell Street factory, 1955.

Right: Lionel Malpass, checking lens powers, 1960.

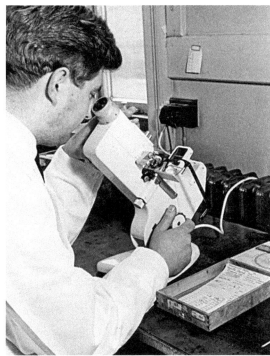

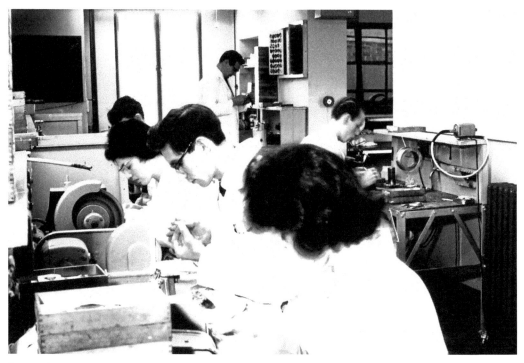

Spectacle assembly at Russell Street, 1960.

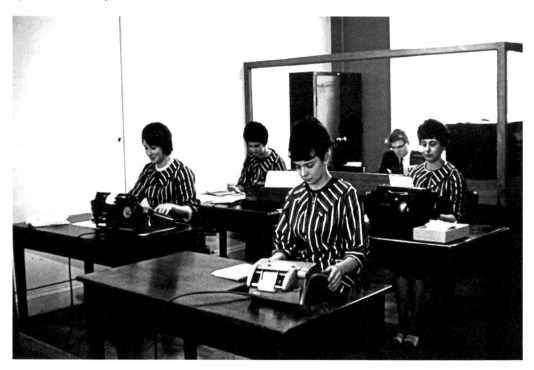

The accounts office in 1965, with head typist Anne Pinkney and her co-workers wearing the distinctive striped uniform. Financial director John Street is in the background.

The Golden Anchor Clothing Co., established in 1898, was the go-to shop for school uniforms in Gloucester. Described as a 'Gentlemen's Outfitters and Suppliers of School Uniform', they stocked school uniforms for the local grammar schools and would place a brand new halfpenny in an envelope of the trousers or jacket for good luck.

The Norville Group Ltd was founded as early as 1898 by Frank Norville as a watchmaker, jeweller and optician and is still family owned today. In 1917 Frank Norville died, leaving a widow and a two-year-old son. Mrs Norville, having no other option at the time, took on a manger, Mr Goodwin, who was an optician, and the business began to concentrate on optical work. In the 1980s, they moved to the old Hatherley Step Works in Tredworth.

In 1899, Gloucester Corporation Electricity established the three-wire low-tension direct-current system of distribution. The plant consisted of two small reciprocating sets. Subsequent additions of similar type and larger size, and later of a steam-turbine driven plant, increased its capacity to 6,200 kw.

William Stephenson Barron was a peripatetic mill engineer who, in 1903, founded his own company, W. S. Barron & Son Ltd. It eventually became one of the country's most prominent mill engineering firms and helped keep the city at the forefront of milling technology in Britain. They operated out of premises in Sweetbriar Street and then at Ladybellegate and Kingsholm. In the 1930s, the firm moved to a larger site on the Bristol Road.

In 1934, an agreement was made between Barron's and Henry Simon Ltd of Stockport to work together as associated companies. In 1964, the two firms merged to become Simon-Barron Ltd.

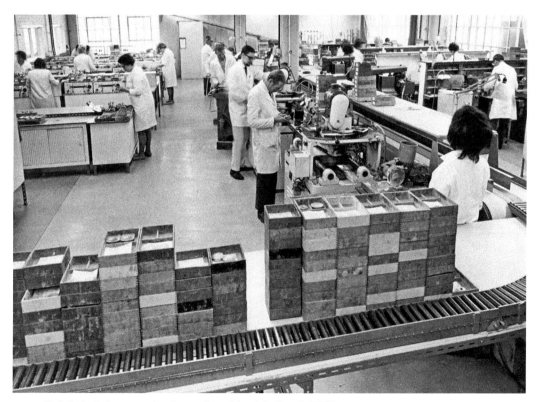

Ophthalmic lens production unit at Magdala Road, 1975.

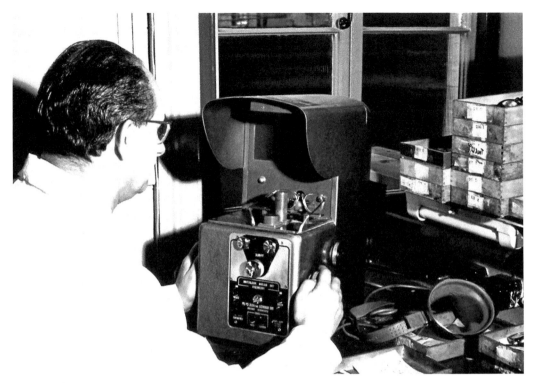

Final verification of finished spectacles.

Frank G Norville, current chairman, at an award ceremony at Magdala Road in the 1970s.

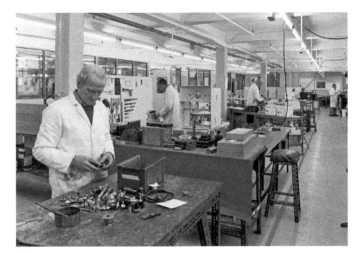

The machine assembly workshops in Paul Street where machines for making spectacle lenses were manufactured, 1985.

GLOUCESTER ELECTRICITY SUPPLY WORKS—ENGINE ROOM

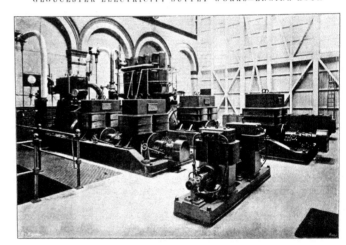

The old engine room at Gloucester Electricity Works.

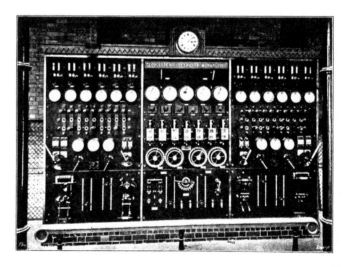

The antiquated switchboard at Gloucester Electricity Works.

Left: A poster advertising W. S. Barron as specialist designers and manufacturers of conveying and elevating equipment.

Below: Bob Manning, a cork worker, in his Eastgate workshop in 1938.

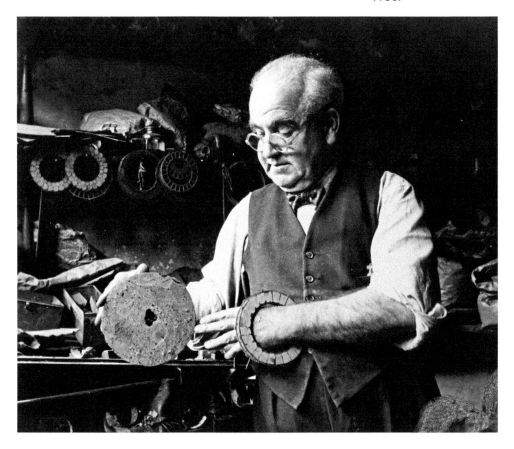

As early as 1791, cork was being imported into Gloucester from Spain and Portugal when the first brig with a cargo of Portuguese wine found its way up the river and regular voyages began. Cork workers were still operating in the city by the outbreak of the Second World War.

FIRST WORLD WAR

During the First World War, Gloucester's industry dedicated itself to military needs. Products of the wagon works, for example, included stretchers and shells. There was also an expansion in engineering, including the building of planes and munitions.

Established in 1915, Williams & James of Lower Barton Street, Gloucester, made small air compressors. They also made manual boosters and testing apparatus. During both wars, they

W&J reducing valves give easy, accurate control of gas and liquid pressure

Meet a range of reducing valves that means easier control than ever over gas, air, steam and oil pressures. W & J valves give leakfree operation, can be serviced while still in the pipeline and are engineered to the extremely exacting standards for which Williams and James are noted — all features that mean *maximum* reliability. Valves are outstandingly efficient too — simple adjustment gives instantaneous control over changing flow and pressure conditions.

RANGE
W & J valves are manufactured in sizes from ¼" to 2" BSP or API for air or gas inlet pressures up to 400 psi. and liquid pressures up to 200 psi. Stainless steel types for corrosive applications are available in ¼", ⅜" and 1" sizes.

Please write for full details by return.

WILLIAMS & JAMES (ENGINEERS) LTD
CHEQUERS BRIDGE GLOUCESTER ENGLAND

Above left: An early advert for Williams & James' pistons and rings from 1920.

Above right: A humorous advert for Williams & James' reducing valves, 1969.

supplied air compressors and engine components to the aircraft industry – Aerolux Paint Spraying and David Compressors were some examples.

National Filling Factory No. 5, a munitions factory in Quedgeley, was a major contributor to the national effort during the First World War. Built in 1916, it provided wartime employment for 6,000 people, most of them women.

During the First World War, there was a shortage of steel, which led to the development of 'sea-going dumb barges' made of ferro-concrete. William Leah, a local architect, was at the forefront of designing these barges for Gloucester Ferro-Concrete Shipbuilding Co. Ltd, established in 1917. Their offices were in Clarence Street and their shipbuilding yard was in Hempsted, where 350 men helped to build six concrete barges as part of the war effort.

The Gloucestershire Aircraft Co. was created in 1917. It was originally based at the Sunningend Works in Cheltenham. Complete aircraft, with wings detached, were transported by road to Brockworth Aerodrome where a new Air Board Acceptance Park had been built; aeroplanes had been assembled and tested here by the Air Board since 1915. By 1918, Gloucestershire Aircraft Co. had reached peak production and were building up to forty-five Bristol Fighters per week.

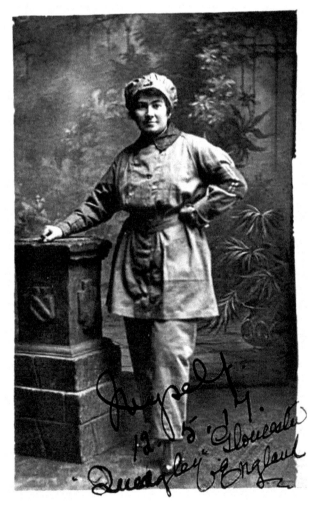

Ann Leahy, one of the thousands of women who worked in the munitions factory in Quedgeley, Gloucester.

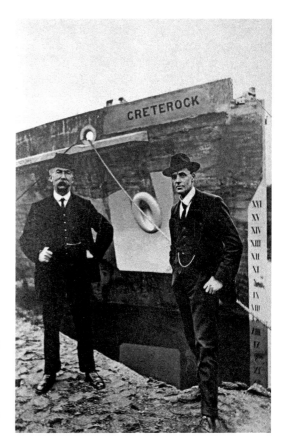

Right: William Leah, right of the picture, standing in front of the *Creterock*, one of the concrete boats he designed.

Below: A Bristol F.2B Fighter of No. 1 Squadron, Australian Flying Corps, in Palestine, February 1918.

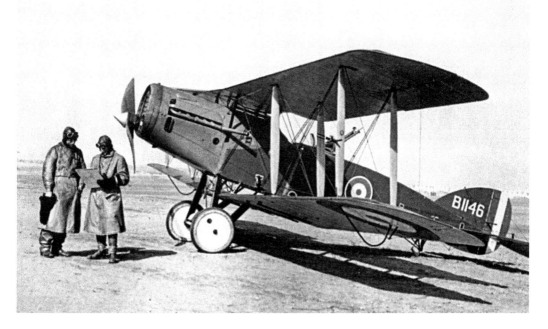

INTERWAR PERIOD

The interwar years in Britain were characterised by high unemployment and striking workers. With the General Strike of 1926 and the economic slump that followed, between 1929 and 1933, few industries were left unscarred. However, in Gloucester local entrepreneurs were still creating famous industries and products.

In 1914, Frank Willoughby Cotton of Gloucester took over a small motorcycle manufacturer, known as Sudbrooks, from the original owner A. H. Camery. He designed a unique triangulated motorcycle frame and patented the idea in 1914, but production was halted by the First World War.

It wasn't until 1919 that the Cotton Motorcycle Co. came into existence. Cotton's famous patent was a masterpiece of modern design, giving perfect riding position with magnificent stability and controllability. Cotton were good at clever marketing phrases. They originated the phrases, 'Speed with Utter Safety', 'Stability Makes Speed Safe', 'Imitated but Unequalled' and 'Win on Sunday, Sell on Monday'.

Having an extremely low centre of gravity, Cotton motorcycles became a popular mount for racing. In 1923, Stanley Woods won the TT aboard a Cotton. A sales boom was created in 1924 after the Cotton swept the first three spots in the Junior TT.

Cotton suspended the manufacture of motorcycles during the Second World War and turned over to the manufacture of war goods. Cotton lasted until 1980, much longer than many other British motorcycle builder.

Alfred Danks Ltd, established in 1912, was a general engineering concern making wrought-iron pulleys. By 1926, they were manufacturing high-grade malleable iron and non-ferrous castings for automobile engineers. In 1929, the company was purchased by Gloucester Railway Carriage and Wagon Co.

By 1926, the Gloucestershire Aircraft Co. had changed its name to the Gloster Aircraft Co., and in 1934 it produced the iconic Gloster Gladiator biplane.

In 1928, additional power was required in Gloucester, which was supplied by the West Gloucestershire Power Co., supplementing the power produced by the Gloucester Electricity Generating Station.

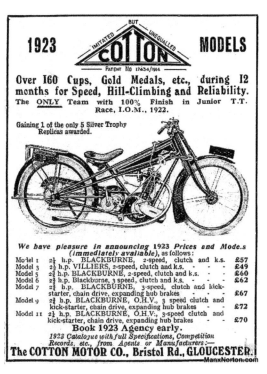

A 1923 poster advertising the prices of new Cotton motorcycles and displaying the phrase 'Imitated but Unequalled'.

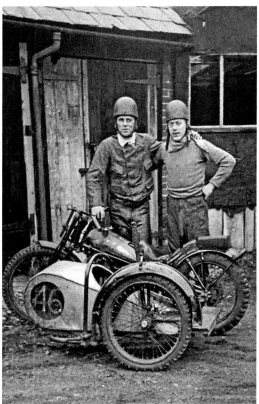

Two local men standing by an early Cotton motorcycle with sidecar. (Date unknown)

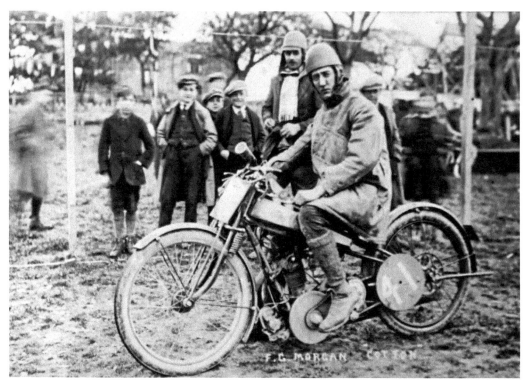

The star factory rider Fred Morgan was victorious at the Isle of Man TTs races riding a Cotton motorcycle.

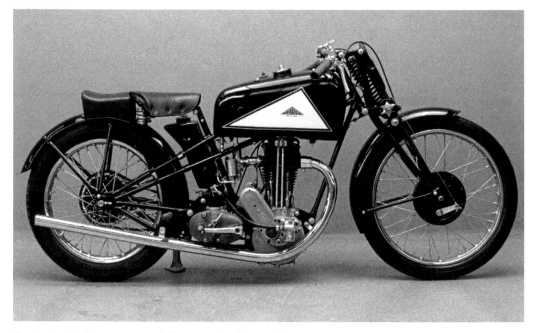

A pristine-looking motorcycle bearing the Cotton logo.

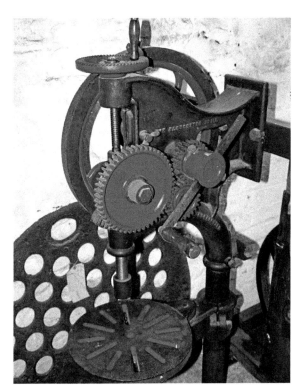

Right: A Pillar Drill, engineered by Alfred Danks Ltd.

Below: The Gloster IV was a British racing floatplane or seaplane of the 1920s. It was built by Gloster Aircraft Co. in 1927 and designed by Henry Folland, their chief designer.

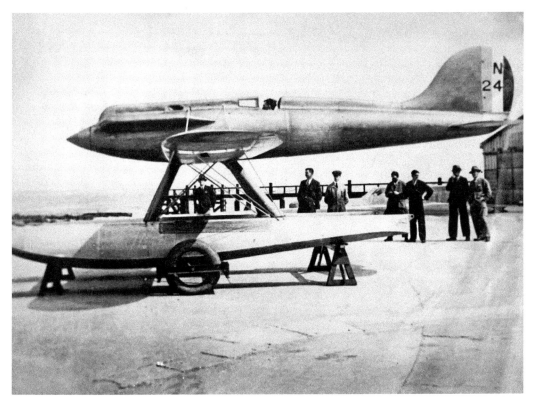

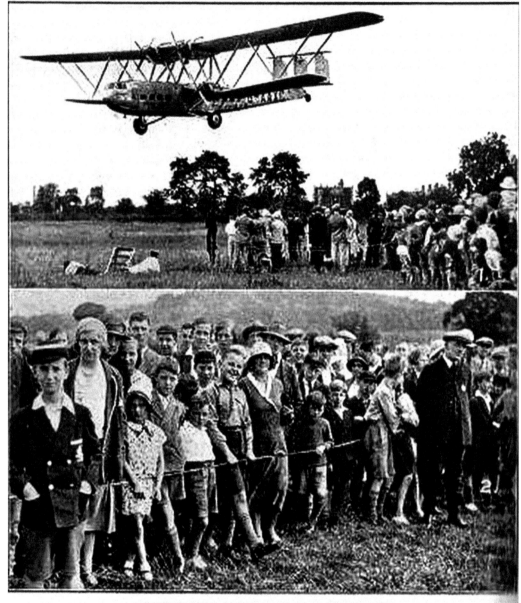

Crowds gather in 1932 to witness take-off at the Brockworth site.

Right: An electricity account or invoice for December 1939 from the West Gloucestershire Power Co. in London Road, related to an early electricity supply to a residential house and commercial bakery in the village of Rogiet, South Wales.

Below: Workers at the Carpet Factory in Llanthony Mill, Gloucester, during the 1970s, preparing the 'beams' of what would become the 'tufting yarn supply'.

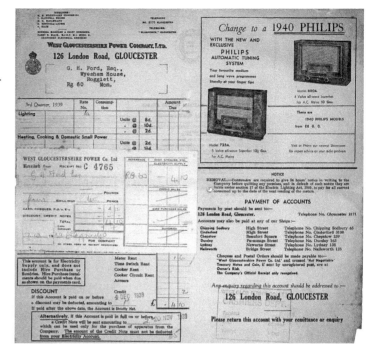

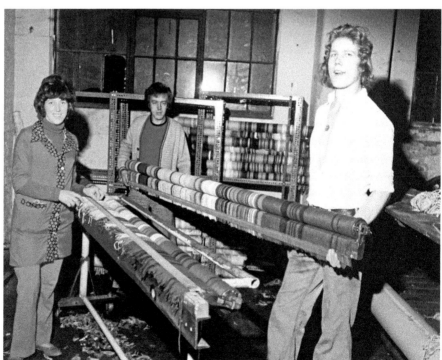

Gloucester Carpet Co. Ltd moved into the old Matthews Furniture factory in Llanthony Road in the 1930s, manufacturing high-quality Axminster carpets. By the 1970s, the market for high-quality carpets was declining, and the business was finally closed down in 1978.

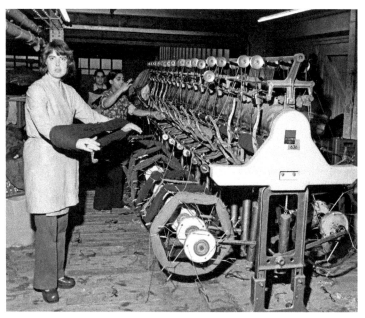

Women working on an old Leesona 636. Yarn was wound onto cylinders, known as Cheeses. The Leesona was a 'hank to cheese winder', largely operated by women workers. The machines were easy to maintain and it was said the only tools really necessary to keep this machine fully maintained were an adjustable wrench, a screwdriver and an oilcan.

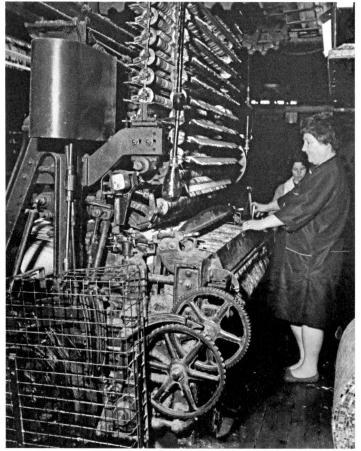

Female workers in the 1970s at the Carpet Factory, working on the loom. The tufting supply beams are stacked horizontally, and to the left at the back of the loom you can see the warp supply, probably cotton.

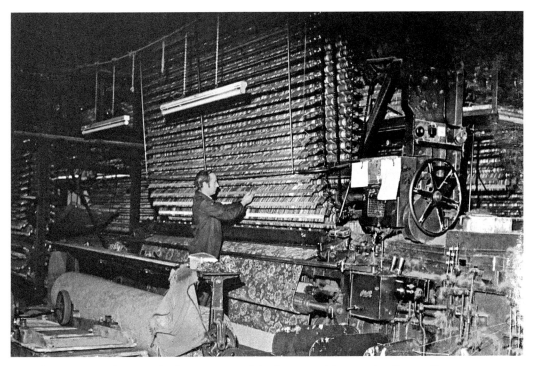

Someone working on the loom – one of the huge machines at the Carpet Factory.

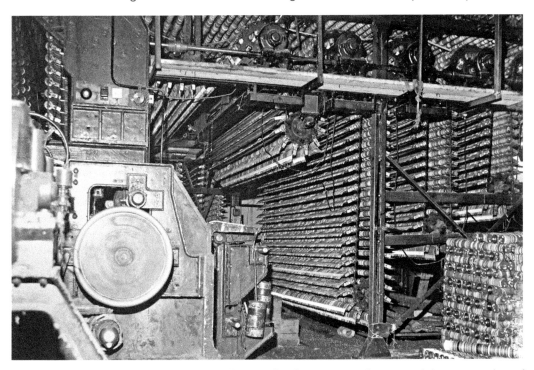

An image of the loom, showing the sheer scale of carpet manufacture and the vast number of tufting beams needed in these intricately patterned Axminster and Wilton carpets.

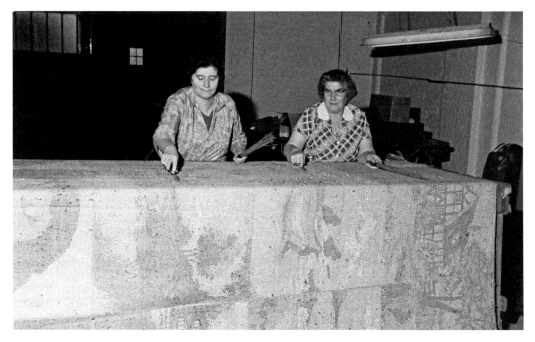

FROM 'PIG' TO PRODUCT
GLOUCESTER
blackheart malleable
and grey iron castings

are under
'ROUND THE CLOCK'
metallurgical control

STAND D.339/238

Although Gloucester Blackheart Malleable and Grey Iron castings are produced in large numbers by a fully mechanised plant, "quality control" is practised at every stage of production. Every "heat" is analysed hourly to ensure strict adherence to customers specifications. This complete scientific control, combined with rigid inspection at all stages of production gives customers castings a uniform structure, which ensures easy machining and exceptional durability.

The new elevator-type electric furnace allows annealing to be carried out in hours instead of days !

Why not talk over your casting problems with Gloucester technicians on the Stand.

GLOUCESTER FOUNDRY LTD., EMLYN WORKS, GLOUCESTER
(A subsidiary of the Gloucester Railway Carriage & Wagon Co. Ltd.)
Telephone: GLOUCESTER 23041 *Telegrams:* 'PULLEYS' GLOUCESTER

Above: Women workers carrying out inspection and correction operations.

Left: Gloucester Foundry, extolling their quality control standards in an advertising poster from 1957.

Gloucester Foundry was incorporated in 1930 to run the Emlyn Works, a foundry in Alfred Street. They made, among other things, malleable iron castings. In 1977, Gloucester Foundry employed 540 workers, but by 1981 it had closed.

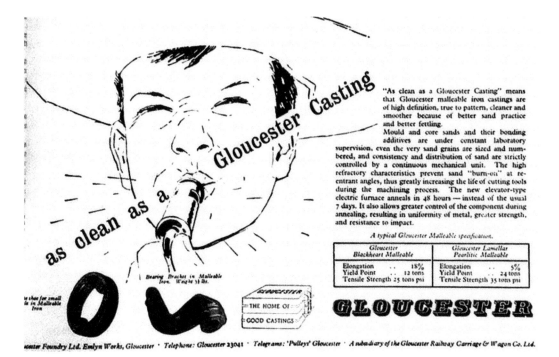

"As clean as a Gloucester Casting" means that Gloucester malleable iron castings are of high definition, true to pattern, cleaner and smoother because of better sand practice and better fettling.

Mould and core sands and their bonding additives are under constant laboratory supervision, even the very sand grains are sized and numbered, and consistency and distribution of sand are strictly controlled by a continuous mechanical unit. The high refractory characteristics prevent sand "burn-on" at re-entrant angles, thus greatly increasing the life of cutting tools during the machining process. The new elevator-type electric furnace anneals in 48 hours — instead of the usual 7 days. It also allows greater control of the component during annealing, resulting in uniformity of metal, greater strength, and resistance to impact.

A typical Gloucester Malleable specification.

Gloucester Blackheart Malleable		Gloucester Lamellar Pearlitic Malleable	
Elongation	18%	Elongation	5%
Yield Point	12 tons	Yield Point	24 tons
Tensile Strength 25 tons psi		Tensile Strength 35 tons psi	

...cester Foundry Ltd, Emlyn Works, Gloucester · Telephone: Gloucester 23041 · Telegrams: 'Pulleyt' Gloucester · A subsidiary of the Gloucester Railway Carriage & Wagon Co. Ltd.

Above: The company appears to have had a sense of humour, as shown in this advertising poster of 1959.

Right: The company were promoting new products with their 'Tensola' pearlitic malleable irons back in 1962.

GET MORE OUT OF MALLEABLE IRON WITH

Below—Differential Cases for the smallest range of private cars. Weight 3 lbs. size 4½" dia. by 3½". Cast in 'Tensola' Grade 11.
Extreme right—Differential Cases for heavy commercial vehicles. Weight 30½ lbs. size 10½" dia. by 5½". Cast in 'Tensola' Grade 11.

GLOUCESTER 'TENSOLA'

MORE STRENGTH
MORE IMPACT RESISTANCE

Gloucester are now producing a range of Tensola pearlitic malleable irons with higher mechanical properties than the British Standard requirements. With tensile strengths ranging from 30 to 45 tons p.s.i., the Tensola range gives the engineer designer a versatile metal suitable for a wide range of applications requiring optimum strength, hardness and ductility combined with easy machineability. These irons can be flame or induction hardened and the spheroidized matrix form is especially suitable for this. Gloucester produces heat-treated and tempered pearlitic malleable irons to the specification of American Society for Testing Materials.
It always pays to discuss your problems with a Gloucester engineer at the drawing board stage.

Gloucester 'Tensola' Pearlitic

	Tensile Strength min.	0.5% permanent set stress min.	Elongation min.
Grade I	30 tons	20 tons	8%
Grade II	35 tons	22 tons	6%
Grade III	45 tons	28 tons	3½%

In addition the following:

B.S. 3333—1961 Pearlitic Malleable Iron

	Tensile Strength	0.5% permanent set stress min.	Elongation min.
P/33/4	33 tons	20 tons	4%

B.S. 310—1958 Blackheart Malleable Iron

	Tensile Strength min.	Yield Point	Elongation min.
B/22/14	22 tons	13 tons	14%

GLOUCESTER FOUNDRY LTD., EMLYN WORKS, GLOUCESTER. PHONE GLOUCESTER 23041 (4 lines)

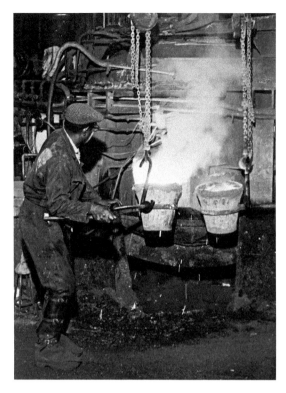

Handling pots of molten metal with bare hands, wearing only a flat cap for head protection – at least he appears to be wearing protective boots!

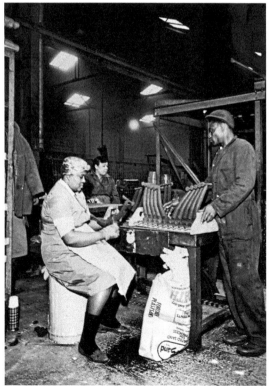

Some of the female workers at the factory.

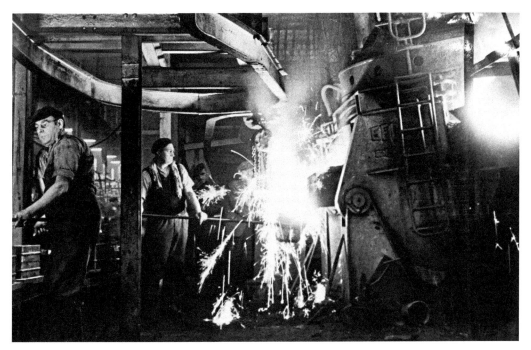

Sparks flying all around. Workers at the foundry, working with bare hands and very little in the way of protective clothing.

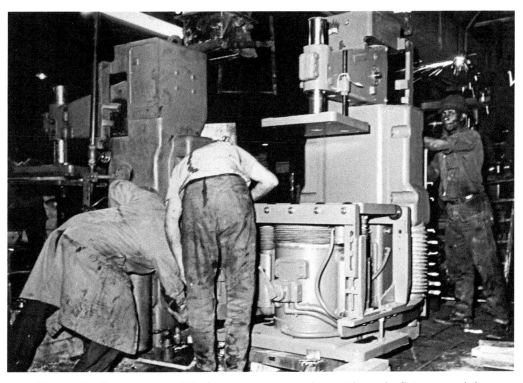

Covered in dirt and grease. Workers servicing a machine with sparks flying around them.

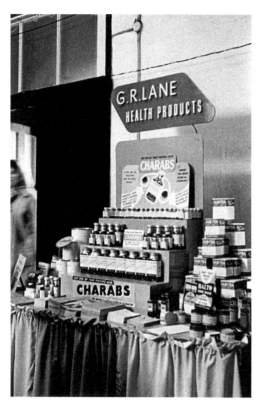

Left: Charabs, one of G. R. Lane's earliest products, *c.* 1950.

Below: Cream filling at Horton Road, 1960s.

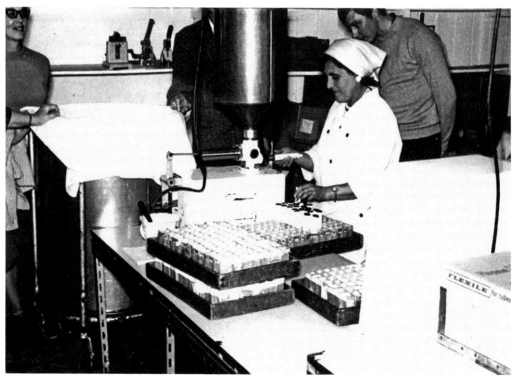

Gilbert Lane first created G. R. Lane Health Products Ltd in 1930. By 1940, the business was operating from premises in Ladybellegate Street. He then moved to the former pin factory in Horton Road (now the Anglo-Irish Club) in Gloucester. His company created a demand for special foods and herbal remedies intended to improve people's quality of life.

In 1974, the company moved to brand new purpose-built premises in Sisson Road. Led by Gilbert's son Roger, a qualified pharmacist, they developed their licensed herbal medicines, supplements and other natural products, which form the basis of their range today. It was also Roger who laid the foundations for bringing together traditional herbal knowledge with state-of-the-art manufacturing facilities. They are well known for traditional products such as Olbas Oil, Kalms tablets and Jakemans sweets.

Today, the company remains in the hands of the Lane family with Roger's daughter, Janet Groves, the current chairman and son Jonathan, commercial director.

Permali Ltd was first registered in 1937 as the New Insulation Co. It changed its name to Permali Ltd in 1951. The company first leased the former Tramways Depot in Bristol Road, making wood veneer-based laminates for electrical insulating and engineering services. In 1956, they opened the West Works in Bristol Road. In 1966, the company commissioned the largest densified wood laminate press in Europe. It was manufactured in Gloucester by Fielding & Platt. They are now market leaders in the manufacture of composite materials for the aerospace, defence, rail, automotive and medical markets. In 1977, Permali employed 1,050 workers.

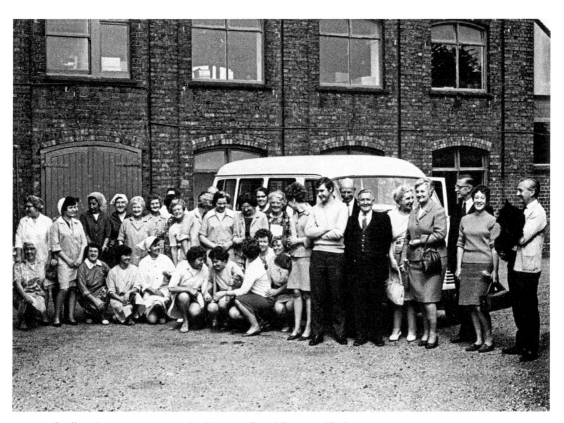

Staff and visitors outside the Horton Road factory, 1960s.

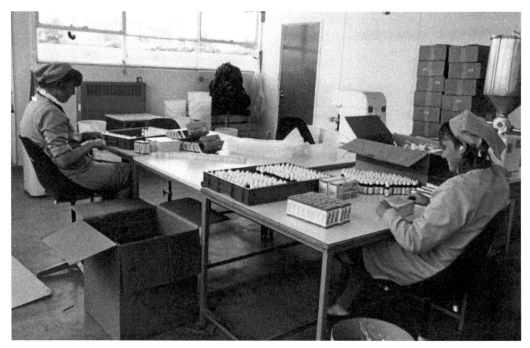

Putting Olbas Oil into cartons, 1970s.

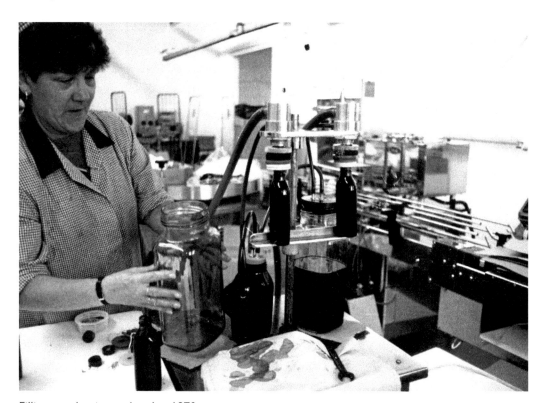

Filling cough mixture bottles, 1970s.

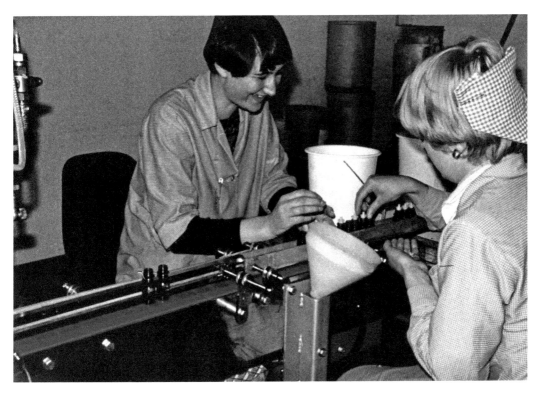

Above: Adding the stopper to Olbas Oil, 1970/80s.

Right: Labelling Dandelion Coffee.

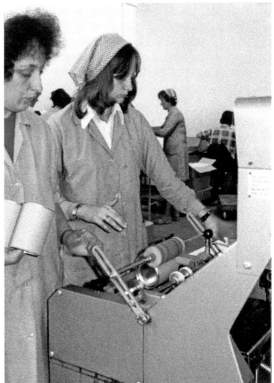

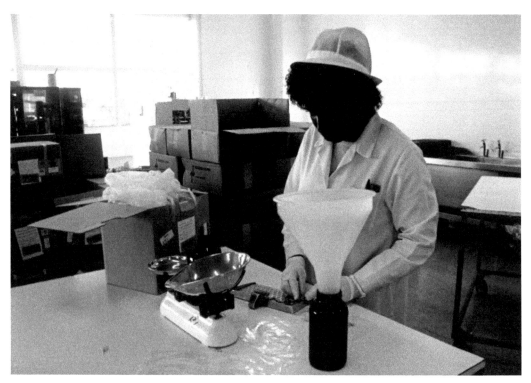

Checking the tablet count.

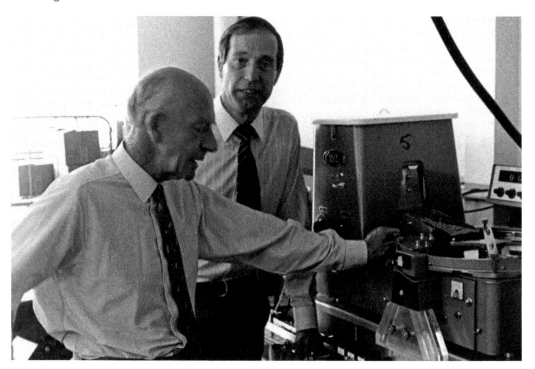

Roger Lane and Paul Simons MD, with the new tablet counting machine.

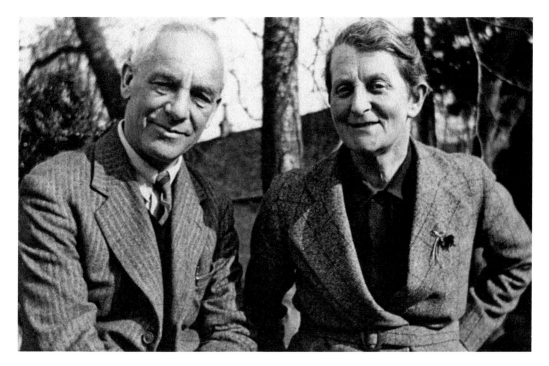

Above: Gilbert Lane, the founder, with his wife Grace.

Right: The largest densified wood laminate press, used by Permali and manufactured by Fielding & Platt in 1966.

Left: The large low-pressure laminating press with a 1,650-ton capacity, having 4.9-metre by 1.95-metre platens, was installed in 1974.

Below: Gerry Hayward celebrating fifty years of employment at Permali.

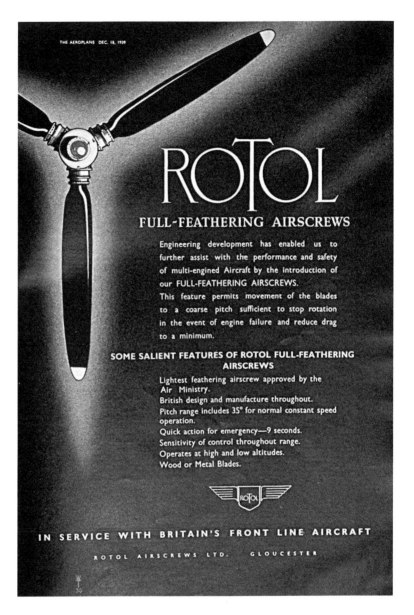

An advert for Rotol Airscrews, which appeared in the December 1939 edition of *The Aeroplane*.

Rotol Airscrews was formed in 1937 by Rolls-Royce and Bristol Aeroplane Co. to take over propeller developments. The name was a contraction of 'Rolls' and 'Bristol'. The company started in temporary premises in Llanthony Road, Gloucester, but transferred to the new factory at Staverton at the end of 1937. Rotol propellers were considered leading edge, equipping Hawker Hurricanes and Supermarine Spitfires.

In the Second World War, Rotol produced over 30,000 airscrews for Hurricanes. By the end of the war, a total of 100,000 airscrews had been produced. In 1943, they changed their name from Rotol Airscrews to simply Rotol.

SECOND WORLD WAR

During the Second World War, many factories turned to military needs. The Wagon Works produced tanks, munitions and Bailey Bridges, while the aircraft industry became one of the principal employers. Between 1938 and 1943, it increased its workforce by 13,430 people. The Gloster Aircraft Co. produced the Meteor, the country's first jet-propelled fighter, and from 1943 A. W. Hawksley Ltd built aircraft. Permali concentrated on supplying large supporting structures used in the development of land and ship borne radar and the production of submarine battery containers, capable of withstanding the shock of depth charge attacks. After the war, industry quickly readjusted to peacetime production.

At the outbreak of the Second World War, Gloster Aircraft Co. (GAC) built over 1,000 Hawker Hurricanes, delivering the last of the 2,750 it constructed in 1942. Production then switched to Hawker Typhoons for the RAF. Although deeply involved with the war effort, GAC is probably best remembered for its involvement with an innovative technology, that of the turbo-jet engine invented by Sir Frank Whittle.

In August 1942, a substantial portion of the Hatherley Works was requisitioned by the Ministry of Aircraft Production and the premises were taken over by the Gloster Aircraft Co., who retained use of the buildings until 1945. In 1959, they purchased the factory at Brockworth for making aero-engines. The Gloster Javelin was the last aircraft designed to bear the Gloster name. The name 'Gloster' finally disappeared from aviation in 1963 after several company name changes.

A. W. Hawksley Ltd of Hucclecote were formed in 1940 by the Hawker Siddeley Group, owners of the Gloster Aircraft Co., to build the Albermarle aircraft designed by Armstrong Whitworth but by the end of the war the Ministry of Aircraft Production requested that A. W. Hawksley switch production from aircraft to designing non-traditional houses because of the urgent need for housing. This resulted in the manufacture of detached and semi-detached aluminium bungalows called BL8s.

Around 1950, the company experimented with building two-storey aluminium houses, but only two were ever manufactured – one of these was at Brockworth, but is now demolished. By January 1951, production of houses had reduced from 5,000 to 500 a year and eventually, in 1959, the factory was sold to British Nylon Spinners.

Van Moppes & Sons can be traced back to the arrival of Louis Meyer Van Moppes from Amsterdam in 1893. He set up a diamond merchanting business in London and the

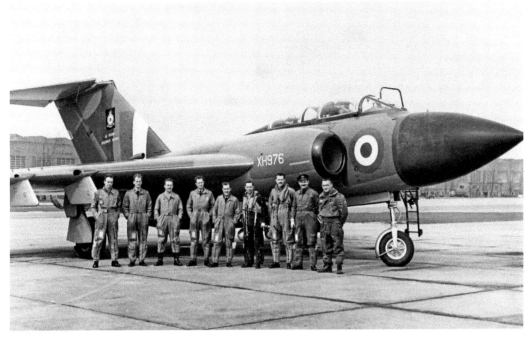

Pilots standing proud next to a Gloucester Javelin.

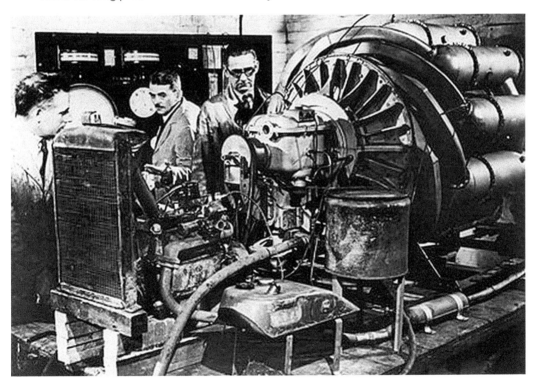

Frank Whittle, in the centre of the picture, working with colleagues on the development of the turbo-jet engine.

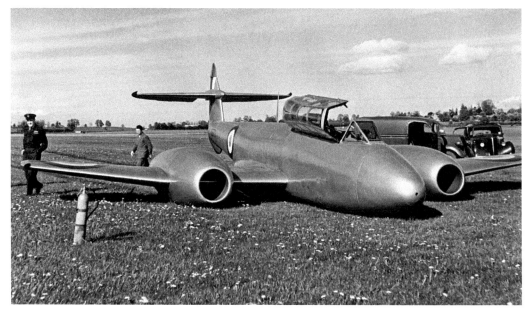

The Gloster Aircraft Co., which built a second factory between 1938 and 1940 on the Brockworth side of the airfield. They also produced the Gloster Meteor, the country's first jet-propelled fighter, the only Allied jet-fighter to be used in the Second World War.

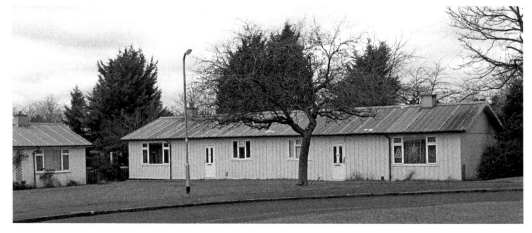

Hawksley prefabricated bungalows, built in 1950–51 in the Wilbury Hills area of Letchworth Garden City.

manufacturing side grew out of this. Impregnated Diamond Products, which was subsequently sold to Van Moppes, began in Belgium in 1932. Peter Neven, of Antwerp, patented a process for combining crushed Industrial Diamond with iron and other metal powders through heating the mixture to the sintering point and pressing. The company continued at the Antwerp plant until the early part of the Second World War when Peter Neven, his key staff and plant were transferred to Gloucester by the Admiralty. It was a dramatic move, completed less than a month before the German invasion of Belgium and involving stripping down the plant in less than two weeks and transporting across a heavily mined North Sea. The principal output of

A female lab technician at the Van Moppes factory, 1950s.

the new company, Impregnated Diamond Products, was the production of cutting tools for the Admiralty and Ministry of Aircraft Production.

In the early 1980s, new product lines such as Diamond Tools and Rotary Truers were established. The company is now part of the international Unicorn Abrasives group, based in Stafford.

POST-WAR PERIOD

After the war, industry quickly readjusted to peacetime production in Gloucester. In the early 1950s, the aircraft industry was the fourth largest employer in the area. National and local government, public services, and the armed forces were among those employing nurses and teachers. After 1948, the docks and associated waterways were acquired by the British Transport Commission and continued to handle a wide range of imports, including raw materials for industry, agricultural supplies, foodstuffs, and oil and petroleum.

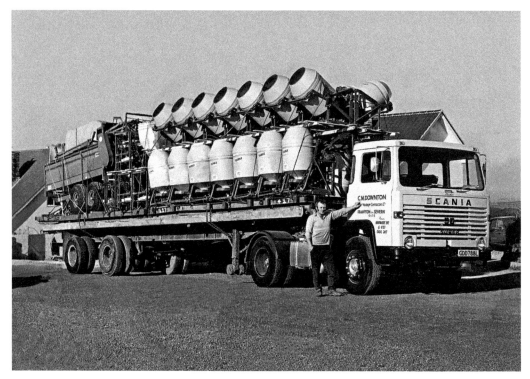

Ken Trunde standing in front of one of Downton's haulage trucks.

C. M. Downton Ltd was formed in 1955 when Conrad Michael Downton, the owner of a small Gloucestershire farm, invested in a gravel-carrying tipper lorry and began moving small loads around the county to supplement the modest income from the farm.

By the end of the 1960s, Downton had built up a fleet of tipper vehicles and was heavily involved in the construction industry in Gloucestershire and along the M5 corridor. In the early 1970s, Downton purchased its first articulated lorry, and the business continued to flourish. Downton diversified its operations and commenced working for the local brewing industry, winning major contracts with Bass Brewers and Flowers Brewery in Cheltenham.

Bryce Berger began production at a factory in Staines, London, and in 1941 moved to Gloucester. They were an engineering manufacturer specialising in pump and fuel injection systems for aircraft and diesel locomotives. In 1958, they moved to the Gloster Aircraft Factory premises to produce pumps for Hawker Siddeley. In 1977, the company employed 1,000 people. They ceased trading in 2011.

T. Wall & Son (Ice Cream) Ltd began life in Acton, London, in 1922. Unilever, the then owners, split the company into two: T. Wall & Son (Ice Cream) Ltd and T. Wall & Son (Meats) Ltd. In 1959, the company doubled capacity by opening a purpose-built ice-cream factory at Gloucester. The building was distinctive because of its revolutionary 'silberkuhl' roof. In 1981, Unilever merged T. Wall & Son (Ice Cream) Ltd with Birds Eye Foods to form Birds Eye Walls Ltd.

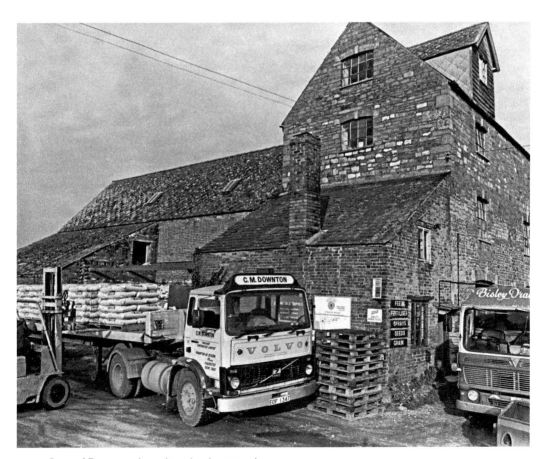

One of Downton's earliest haulage trucks.

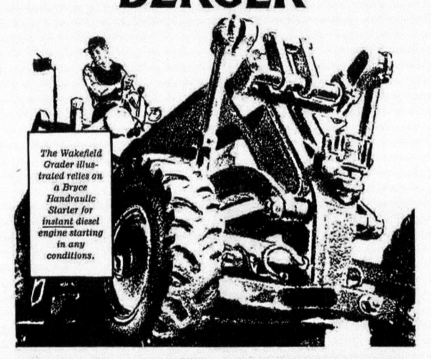
An advert that appeared in the Gloucestershire Association of Boys' Clubs' Handbook and Annual Report for 1966–67, offering employment in the engineering company.

LATE TWENTIETH CENTURY

Although Gloucester experienced a period of prosperity during the 1960s, it also saw a decline in foundry work and engineering. By the 1970s, industrial decline had worsened. The decline in manufacturing and the resulting loss of jobs was only partly compensated for by new businesses sprouting up in Gloucester, but it was nothing on the scale of the traditional manufacturing and engineering industries that had contributed to Gloucester's wealth.

Sir George Herbert Dowty was an English inventor and businessman who founded Dowty. The business originated in 1937 as Rotol Airscrews Ltd. By the time, the Second World War had broken out, the company was known as Dowty Aviation and was making hydraulic systems in planes in Britain, Canada and the United States.

Rotol and Dowty merged in 1960 to form Dowty Rotol, later to be known as the Dowty Group, and in 1968 Dowty Rotol introduced the first fibreglass propellers for hovercraft. In 1977, the Dowty Group employed 4,300 workers.

British Nylon Spinners (BNS) was a British company set up in 1940 and jointly owned by ICI and Courtaulds to produce nylon yarn. The product was badly needed to make parachutes, especially after Japan's entry into the war in December 1941 blocked supplies of silk. Bri Nylon was first registered as a trademark in 1961. In 1962, British Nylon Spinners took over a site near the old Gloster Aircraft Co., employing people who had been made redundant by the closure of the famous aircraft company. They began the production of Nylon 66, which was an industrial yarn used in the making of tyres. In 1964, BNS was absorbed into ICI's existing fibres operation, ICI Fibres.

Mecanaids Ltd was set up in the early 1980s, making equipment for hospitals and for people with disabilities. In 1984, they demolished the former Stephens' Jam & Pickle factory in Catherine Street to extend its operations. The company patented many of their inventions. It is now known as Arjo Huntleigh and still operates out of Catherine Street.

Turnbull & Asser was founded in 1885 by Reginald Turnbull (a hosier) and Ernest Asser (a salesman) when they opened a hosiery in St James's, London. The company set up a sewing factory in Alfred Street, moving in 2013 to a modern factory in Quedgeley.

Edward VII was the first to award a royal warrant, an honour still bestowed today; HRH Prince of Wales issued his first royal warrant to the company in 1980. The prince is also a long-time customer of Turnbull & Asser, and visited the Gloucester factory in 2013.

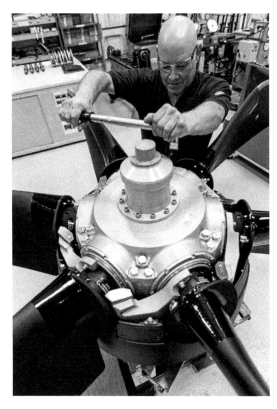

Working on a Dowty Propeller at the Staverton site.

It's **BRI·LON** for knitwear for men who keep a sharp look-out for the newer trends in colour, texture, style.
It's **BRI·LON** for the sweater-shirt so much in demand by men who ask for comfort-plus whether at work or play. A winner by *Wolsey*

In rustic tan, champagne, greenstone, buff, forth blue, navy. *With short sleeves, approximate price 39/6d. With long sleeves, approximate price 42/6d.*

✱ Registered Trade Mark of British Nylon Spinners Limited

A 1961 clothing advert for Bri-Lon, a registered trademark for British Nylon Spinners Ltd.

Above: Part of a Mecanaids Autolift, showing details of patents.

Right: Bette Elton and Kathleen Cope, the twins who have worked together at their Gloucester factory since 1964. Now factory floor manager and senior supervisor respectively, the dedicated sisters have over a century of experience between them and represent 'the best of the best in shirt making'.

Since its establishment, Turnbull & Asser has become the outfitter of choice to leaders of states, captains of industry, film stars and artists alike including, Charlie Chaplin, Pablo Picasso, President Reagan, the Beatles, Sean Connery, George Lazenby, Frank Sinatra and Sammy Davis Jr.

TWENTY-FIRST CENTURY

By the twenty-first century, much of the city's large-scale heavy engineering firms had closed, replaced by a growth in service industries. Advanced technology firms such as Digital Barriers BAE Systems began to spring up, but gone were the days of massive industrial concerns. The latest additions to the digital age is the multimillion-pound government facility built in 2017 to help tackle cybercrime at Brockworth, and the security-conscious high-tech secret government building at Barnwood Square.

Emma Willis started her shirt-making business in 1987 and set up her factory operation on The Cross in Gloucester in 2010. In 2013, they moved their factory to Bearland House, where they specialise in traditional shirt-making techniques using luxurious Swiss and West Indian Sea Island cottons.

Digital Barriers is a high-tech company, established in 2009, specialising in surveillance, security and safety. They develop technologies such as stand-off body scanning to detect concealed weapons and explosives, and also zero-latency video streaming on low bandwidth

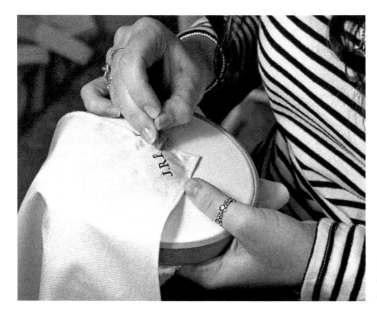

Monograms being hand embroidered by skilled embroiderer Helen.

The Emma Willis factory at Bearlands House in the centre of Gloucester.

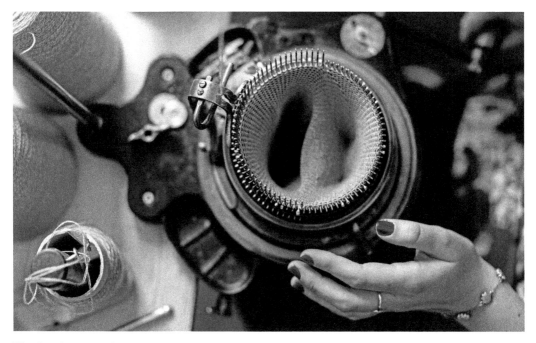

The hand-operated Victorian sock loom, purchased by Emma Willis to weave their range of woollen socks.

networks for security purposes. Although based worldwide, the company's vice president, Neil Hendry, is a former Gloucester schoolboy who attended Sir Tommy Rich's School. He runs the operations at their Gloucester base.

Their ThruVis technology is a highly sensitive camera, which works like an X-ray machine, but can detect non-metallic objects such as explosives and their EdgeVis Shield is an integrated surveillance platform that provides a digital wall along unlimited lengths of border, delivering real-time intrusion alerts, with live video streaming across all types of environment, including the most remote locations and hostile of locations. In 2017, it was linked to President Trump's election promise to build a 2,000-mile wall between America and Mexico. Both products have been employed by military forces and border controls around the world.

BAE Systems in Brockworth offers a range of cyber security and intelligence products and services to protect and enhance the connected world. They help nations, governments and businesses around the world defend themselves against cybercrime, reduce their risk in the connected world, comply with regulation and transform their operations.

They protect financial institutions across the globe from financial and reputational harm, protect institutions and individuals from loss of monetary and information assets, and provide managed network monitoring and protection of network assets and security infrastructure.

BAE provide comprehensive cloud and digital capabilities to government and commercial customers. They make the tools and provide the skills that help nations form intelligence to protect their citizens from harm, and help secure their networks and organisations from the most advanced hostile threats and cyberattacks.

GCHQ at Barnwood Square is an extension to the government's spy network and reflects Gloucester's changing industry and workforce. It is an extremely high-tech, security conscious building, housing some of the most highly skilled professionals in the security industry.

Karen Walsh was born in Gloucester and began her career in 1992 learning how to sew every part of a shirt with a local company. She joined the Emma Willis team in 2009, specialising in sewing shirt fronts and shoulder joins. Karen's sister Christine runs production and her two nieces Emma and Chloe also work at Emma Willis, in finishing and sewing respectively.

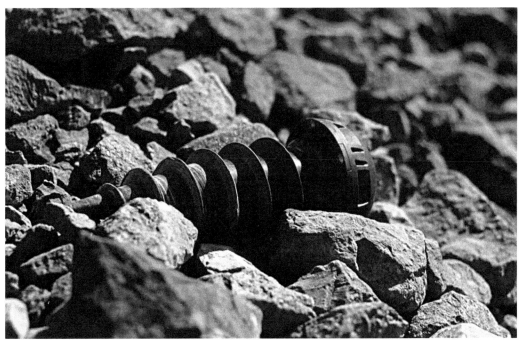

A ground sensor developed by Digital Barriers and used in the making of a secure digital wall for remote border protection. The screw-shaped Unattended Ground Sensor (UGS) is buried underground. It processes seismic technology so advanced it can differentiate between small animals, vehicles and humans as well as tunnelling activity.

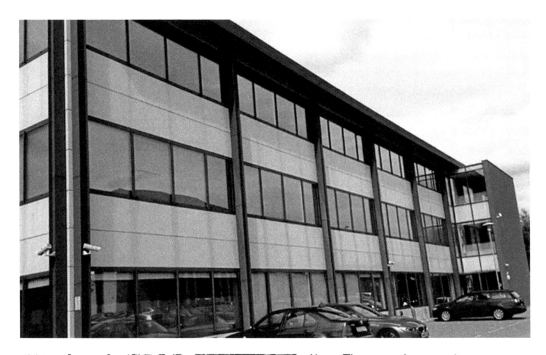

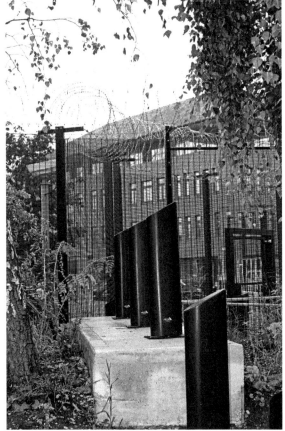

Above: The new cyber security unit at Brockworth, built for BAE Systems and employing a highly skilled workforce.

Left: GCHQ, Barnwood Square, takes security seriously. The perimeter is lined with anti-ram barriers.

GCHQ, Barnwood Square. Along with anti-ram barriers, the perimeter is also secured by high metal fencing, razor wire and security cameras.

ACKNOWLEDGEMENTS

I would like to thank Sarah Orton and staff at the Gloucester Life Museum and David Rice of the City Museum, Gloucestershire Archives, Gloucester Railway Carriage & Wagon Museum, Gloucestershire Police Archives, the Royal Airforce Museum and the San Diego Air and Space Museum Archive.

Again, huge thanks go to Tom Tunstall for his photographs. Also thanks to A. Rainer Haeßner, Thryduulf, Skeezix1000, Simon Trew, Paul Townsend, Philip Halling, Derek Harper, Michael Pitfield, Barry Watchorn, Shaun Hill, Gloucester Museum's Service and Essence Lifestyle.

For reference, I am indebted to *Grace's Guide: Coaley, The Macmillan Guide to the United Kingdom 1978–79* and Historic England.

Also, I would like to thank Tony McHugh from North Carolina, retired employee of the Leesona Co.; Gus King, former CEO; and John Carter, former employee of Permali; Frank Norville, current CEO of The Norville Group Limited; Robert Tyler of Goodwins Funeral Services; Marc Cambridge of F. J. Cambridge & Company; Shaun Bird from Turnbull and Asser; Kristal at Emma Willis; Janet Groves, Chairman of G. R. Lane Health Products Ltd; Geoff Davis, Chairman of Helipebs; and Sandra and Chris Drury of Nicks Timber.